Contents

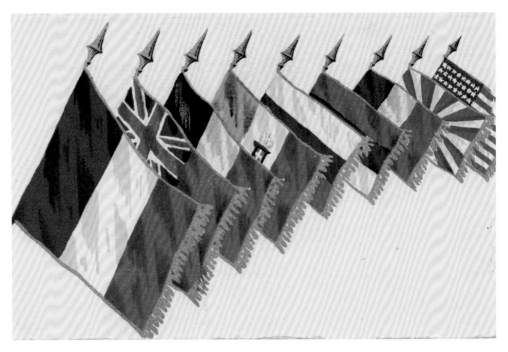

Allied Flags (*Above*) and Christmas Greetings (*Below*)

The most common symbols relating to the Allies were a series of flags and postcards, which can be dated by the flags shown above. For example, the card must be post 1917 as it contains the USA flag, while the one below must be from before teh American entry into the war. Flags appeared in many types of cards, the one below being used as a replacement Christmas card. Interestingly, the postcard does not contain the full Union Jack.

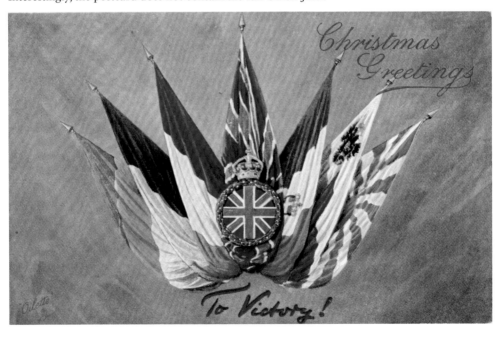

1

Introduction

A Brief Overview of the War

The trigger for the First World War was the assassination of Archduke Franz Ferdinand, heir to the Austro-Hungarian throne, in Sarajevo on 28 June 1914. This assassination of a minor European royal meant it was only a matter of time before European alliances would see the conflict grow to incorporate all of Europe, and then all of the world's superpowers. The two opposing alliances were:

The Triple Entente of the United Kingdom (and the British Empire), France and Russia, who were later joined by Serbia (1914), Japan (1914), Italy (1915), Portugal (1916), Romania (1916), Greece (1917), and the USA (1917).

The Central Powers of Germany and Austria-Hungary, later joined by the Ottoman Empire (1914) and Bulgaria (1915).

The war started on 28 July, when the Austro-Hungarians invaded Serbia. During the nineteenth and early twentieth century a variety of alliances had, in general, maintained peace in Europe. However, the dispute between Austria-Hungary and Serbia brought into play the alliances, and the war rapidly spread. The Russian Empire, unwilling to lose its influence in the Balkans, came in on the side of Serbia on 29 July. On 30 July Germany mobilised in support of Austria-Hungary, declaring war on Russia on 1 August. On 3 August, Germany declared war on France, and on 4 August Germany invaded neutral Belgium to attack France in an attempt to quickly wipe out the French army.

When Britain's request to keep Belgium neutral went unheeded, they were obliged to come to their defence through the 1839 treaty with Belgium. Britain declared war on Germany on 4 August. Britain and Germany had been in an arms race since the 1870s, and now these two mighty military forces would come face to face. Most European countries had been building up their armies, and between 1908 and 1913 they had increased their military spending by 50 per cent as they all saw that war was inevitable.

The fighting on the Western Front soon drew to a stalemate, when the German advance on Paris was halted. Both sides formed trenches from where the rest of the war was fought in France and Belgium. On the Eastern Front, the Russian army surprised

the Germans by being better prepared than expected, and was successful against the Austro-Hungarians. However, they were stopped in their invasion of East Prussia by the Germans. The Russian successes meant Germany had to fight on two fronts, something they had wished to avoid.

With the Ottomans entering the war, fighting spread into the Caucasus, Mesopotamia and the Sinai. The fighting with the Ottomans not only saw trench warfare in Turkey, most famously at Gallipoli, but also open warfare in the desert. T. E. Lawrence, better known as 'Lawrence of Arabia', had been an archaeologist in the region and at the outbreak of war was commissioned by the British to lead an Arab insurgency in the Middle East. He fought alongside the Arab Irregular troops on raids along the Ottoman railroad that ran through modern-day Turkey, Syria and Jordan. He helped coordinate the Arab attacks to meet British objectives, and tied up the Turkish troops in protecting and repairing the railroad. Unfortunately, the promises made to the Arab leaders that they would be given their own land, and believed by T. E. Lawrence, were not honoured and at the end of the war, the British and French divided up the former Ottoman Empire in the Middle East between themselves.

In Africa, British and French colonies fought against the colonies of Germany from the 7 August 1914, and the African conflict ended two weeks after the 1918 Armistice in Europe with the surrender of Colonel Paul Von Lettow-Vorbeck, leader of the German colonial forces, who had been fighting a guerrilla war. In the Pacific, Australia, New Zealand and Japan seized all German territory in the region within a few months of the start of the war, with the exception of a few areas holding out in New Guinea.

One of the turning points in the war was when the USA entered in 1917. Many believed that the sinking of the unarmed passenger ship RMS *Lusitania* in 1915, sailing from New York to Liverpool, would have brought in the Americans, but President Woodrow Wilson refused to be drawn in at that point. However, the continued German submarine campaign targeting American-owned ships eventually drew the USA into the war. This decision was unpopular in the USA, where an estimated 60 per cent of its citizens felt the USA should have maintained its neutrality.

In most places the fighting draw into a prolonged stalemate, with massive waste of human life due to meaningless charges at the enemy trenches. Soldiers became disillusioned with their leaders and the war's justification, and at home the civilian population grew tired of hardship and the constant bad news from the front. This combination proved fatal for several countries. In 1917, Russia had to withdraw from the war as the Tsar was overthrown in a revolution. In Germany the same was looking likely, so they made a final attempt to win the war on the Western Front with a massive offensive. This was thwarted by the Allies, and on 11 November 1918 an Armistice was agreed with the fighting ending in Allied victory. The Treaty of Versailles, which confirmed the end of all hostilities, was signed on 28 June 1919. The treaty made it clear Germany acknowledged responsibility for the war, and agreed to pay massive war reparations while also ceding territory to the victors.

The signing of the peace treaty in 1919 also showed how the world had changed. In 1914 Australia, Canada, New Zealand and South Africa automatically entered the war as dominions of Great Britain, but in 1919 these four countries were individual

signatories of the Treaty of Versailles, showing their developing independence. The war had devastated the imperial powers and by 1919 the German, Russian, Austro-Hungarian and Ottoman Empires ceased to exist and central Europe was formed into several smaller states. Over 60 million Europeans, and 10 million men from other countries, were mobilised into military services. Around 10 million of these fighting men were killed in action. A further 7 million civilians were killed, making a total of 17 million people being killed during the war, almost 1 per cent of the world's population. On top of these deaths, a further 20 million were wounded. Of the 10 million service men killed, 6.8 million were killed in action, with the rest dying from disease, accidents or as prisoners of war.

For those who died fighting, they were often buried at, or near to, where they fell. It was not until after the war that the remains of many were moved to formal graveyards, with the now familiar and iconic lines of white headstones. In these graveyards are large monuments to record those whose bodies were never found or identified, the most famous of which is the Menin Gate Memorial at Ypres, Belgium, unveiled on 24 July 1927.

Some historians claim the military leaders were incompetent, while others argue that the officers were competent, just operating in difficult and unimaginable circumstances. In truth, the reality lies somewhere in between. Bad decisions were made that wasted human life, but the battlefields and conditions made fighting almost impossible, and the employment of new weaponry, such as machine guns, made mass killing easy. The horrific loss of life, and the physical and mental damage caused to many of the returning service personnel, was a major cause of the populations of Germany and Russia rising up against the authorities, and the ending of the war. It was called the lost generation because so many men were killed, maimed or left mentally scarred.

The League of Nations was formed, as a result of the Paris Peace Conference, in the hope that it could prevent future wars through negotiation, arbitration and limiting militarisation. However, the League, which did have limited success, failed when Germany, Italy, Spain and Japan withdrew in the 1930s and Germany, who felt they had been unfairly sanctioned by the terms of the 1919 treaty, went on to develop its military power, which ultimately led to the Second World War.

A Brief Overview of Wartime Postcards

The first major war to be covered through photography was the Crimean War (1853–56) quickly followed by the American Civil War (1861–65). However, these photographs had limited circulation and would be seen as the precursor to the modern-day war photographer. It was not until the Boer War that postcards became a medium for distributing images and messages. These generally consisted of photographs taken in Great Britain of soldiers preparing or returning from war, cartoons and propaganda material.

The first quarter of the twentieth century is often seen as the heyday of the postcard. They depicted everyday scenes and were part of the way society recorded

daily life. Into this period of mass social commentary, postcards that recorded the events of the Great War, later known as the First World War, were thrown. It would be unthinkable today to produce postcards of battle-scenes for mass sale, but this is exactly what happened during 1914–18, sometimes not protecting the public from the true horrors of war.

Scenes of damage and destruction were popular at the start of the war. But as the war dragged on, demand seemed to drop for these kinds of image, and the official war-style postcards started to dominate. The content of these postcards was censored and included positive images often showing upbeat, posed soldiers. Early postcards were often marked by dates, 1914, or 1914/15, suggesting that people were expecting a short war, but dates became less common as the war went on. This does make identifying some of the scenes difficult, as many towns and villages became involved in more than one battle as the frontline moved. Postcards showing battlefield scenes became popular again after the war ended, partly acting as a social record of the damage, and also meeting the needs of tourists visiting the former battlefields.

The vast majority of battlefield postcards produced were from Europe. The war was also fought in Africa, the Far East, Near East and on the seas, but these campaigns had fewer postcards. Many postcards were produced by local French and Belgium photographers. However, newspapers wanted to be among the first to record scenes from the battlefields. This led to series of postcards being produced by newspapers to try and outdo their rivals. In 1916, the *Daily Mail* gained a strong advantage when they struck a deal to publish the official British war photographs. Not to be outdone, the *Daily Mirror* negotiated with the Canadian authorities to do the same.

Surprisingly, it appears most of the images made their way past the official censors, especially if they raised public morale back in the UK, but often messages written on the back had to be short and sweet. An officer would read each postcard, striking out inappropriate words with a blue pencil. Once passed they had a censors' mark stamped on them. The shape of the stamp indicates its date: circles and squares were used in 1914, the triangle in 1915, hexagonal and oval in 1916 and rectangular in 1917 and 1918. The number on the censors' stamp signified a specific field post office.

For British and Allied forces, there were mobile post offices at the camps and near to the front, as shown in the postcard on page 2, at which the men could not only send their postcards, but also look through a range for sale. Postcards provided an easy format for the Army censors to read and hopefully pass. To further aid censors, the field service postcard was introduced. It allowed a soldier to enter minimal details that notified their family and friends in the UK that they were alive and well, or injured, at the time of writing the card, and acknowledged receipt of letters from home.

Battle scene postcards also became a main source of propaganda never to be matched in any subsequent war. Other propaganda cards included witty images and one-liners. There were also home front images, and even though it is true postcards do exist for later conflicts, most notably the 'London Under Fire' series showing the Blitz in London during the Second World War, later wars were dominated by informal and official photographs that did not contain a postcard back.

Censors' Marks on Postcard

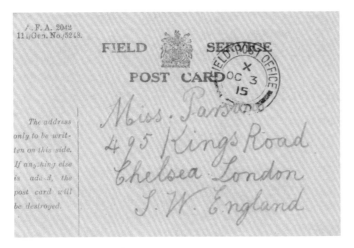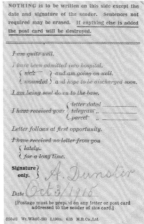

Field Service Postcard
Field service postcard sent in October 1915 to Miss Parsons, from Private Albert Dunster who served with the Devonshire Regiment in France, from 27 July 1915.

A popular pre-war portrait format was *cartes de visite*, studio photographs often advertising the photographer's studio on the reverse. As many young men wanted to leave their loved ones an image of themselves, or carry a picture of their sweetheart or family members with them, the war saw a dramatic increase in studio portraits being produced in the real photographic postcards format. These were not mass-produced postcards, as they had very limited print runs to meet the needs of the person being photographed, but on the reverse the photographer placed a postcard format so the image could be sent through the post. It might be a technicality that many First World War portrait images of serving men were printed with postcard backs, and many were not sent but handed to loved ones, but they illustrate the postcard fad of the time. Unfortunately, in most cases these portraits now depict anonymous men in uniform and their fate is lost in the mists of time.

There were also studio photographers who went around the local military training camps in Britain to take photographs of individual men or groups of men, and in the latter case the men could then split the cost of having the postcards produced. These group photographs ranged from having a formal appearance (groups of men in neat uniforms) to a more informal tone (where men might not be wearing a tunic, or the tunic undone and their caps at an angle). (see pages 21 and 22).

In the UK, the postcard offered two faces on which propaganda messages could appear. The image side allowed a pictorial propaganda message, while the reverse allowed the letter to be franked with a message, often promoting government programmes like war bonds (shown on left). On the Home Front there were special postcards produced showing illustrations of war work. These were produced by A. M. Davis & Co. from material supplied by the Ministry of Information. They were issued in connection with the National War Committee's Campaigns and were sold to raise funds. These were known as the 'War Bond Campaign Postcard'. During and after the war, postcards were also produced to raise funds for charities such as the YMCA Hut Fund, orphaned children, wounded soldiers and the Red Cross.

The following pages show the range of postcards produced and help tell the story of the war through this medium.

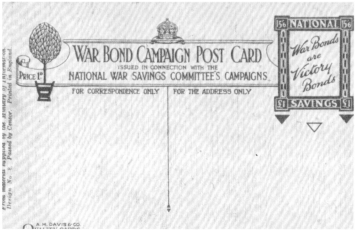

2

The Leaders

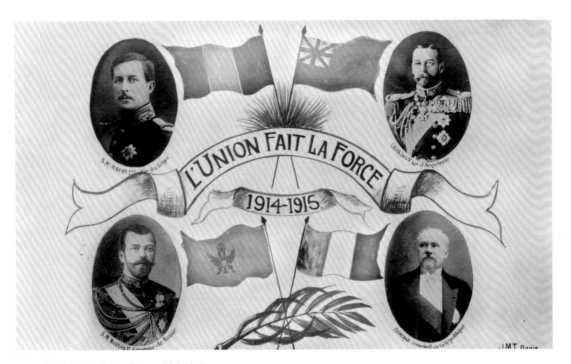

L'Union Fait La Force, 1914/15
This French postcard contains a portrait of the leaders of the Allied countries in 1914: King Albert I of Belgium, King George V of Great Britain, Tsar Nicholas II Emperor of Russia and President Poincare of France.

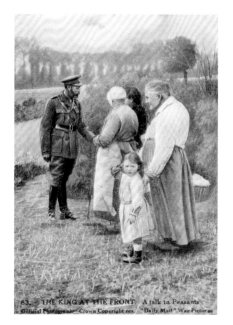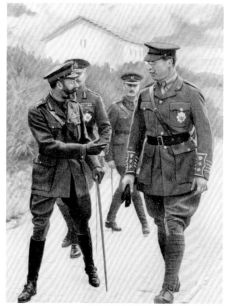

King George V Illustrated, as Part of the *Daily Mail* War Picture Series
King George V is seen talking with locals (*left*) and with King Albert I of Belgium
(*right*). They are both part of the *Daily Mail* Series XI and were used to show the King's
personal interest of the front.

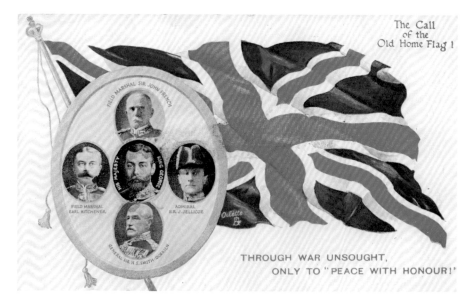

The Call of the Old Home Flag!
The title of the card is the name of a poem by Walter E. Grogan. Pictured in the centre
is King George V, surrounded by the military leaders; Field Marshal Sir John French,
Admiral Sir J. Jellicoe, General Sir H. S. Smith-Dorrien and Field Marshal Earl Kitchener.
The card was part of the 'Oilette' series from Raphael Tuck & Sons postcards.

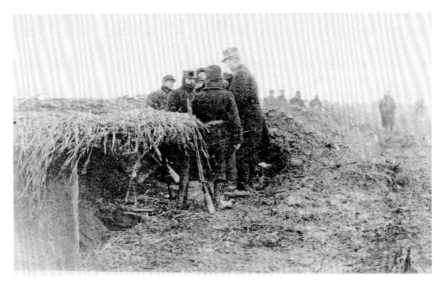

King Albert I of Belgium Visiting Troops at Avecapelle, 1915

Albert I reigned as King from 1909 until his death in 1934. He refused to allow German troops to pass through neutral Belgium, which led to most of Belgium being occupied for the entirety of the war. As Commander of the Army Group of Flanders, consisting of Belgium, British and French Divisions, Albert I led the final offensive of the war that liberated occupied Belgium, and he, with his family, returned to Brussels a hero.

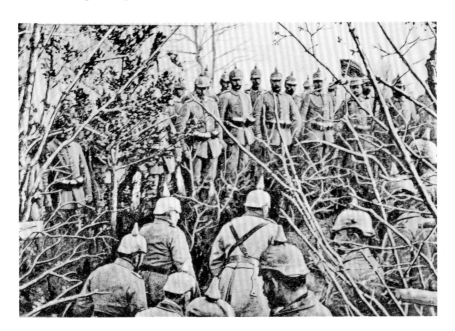

Kaiser Wilhelm Visiting the German Trenches

Kaiser Wilhelm wanted to be hands-on in the war, which included visiting the trenches. With the inevitability of defeat in 1918, Wilhelm II was exiled to live out the rest of his life in the Netherlands, even though many saw the war being a direct result of his desire to expand German territory and wanted him tried for war crimes.

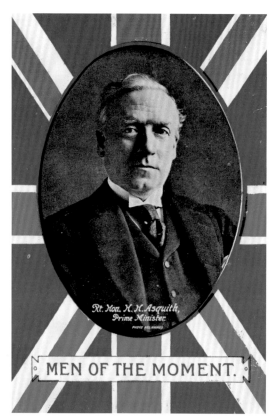

MEN OF THE MOMENT.

Rt. Hon. H. H. Asquith,
Prime Minister.

Herbert Henry Asquith, 1st Earl of Oxford and Asquith, (1852–1928) Asquith served as the Liberal Prime Minister of the United Kingdom from 1908 to 1916. As Prime Minister he led the nation into the First World War, but a series of military and political crises led to his replacement in late 1916 by David Lloyd George.

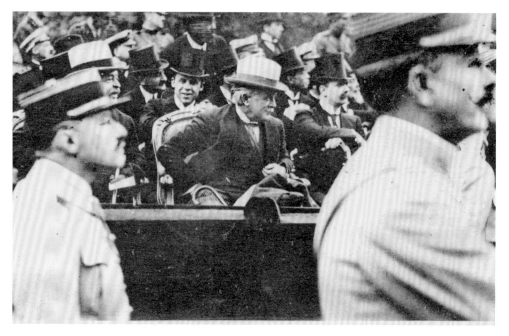

David Lloyd George Visiting Paris, 4 July 1918

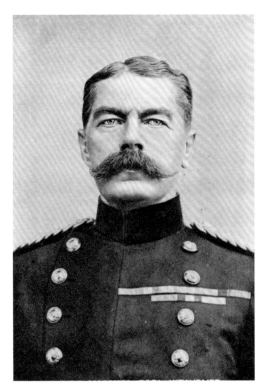

Field Marshal Earl Kitchener (1850–1916),
Postmarked 30 October 1914

In 1914, Lord Kitchener became Secretary
of State for War. Foreseeing a long war, and
the need to extend the Regular Army, he built
up the largest volunteer army the world had
seen. His face became famous through the
'Your Country Needs You' poster campaign.
He was blamed for the shortage of shells
in 1915, and was stripped of control over
munitions and strategy. Kitchener was killed
in 1916 when the ship taking him for talks in
Russia was sunk by a German mine.

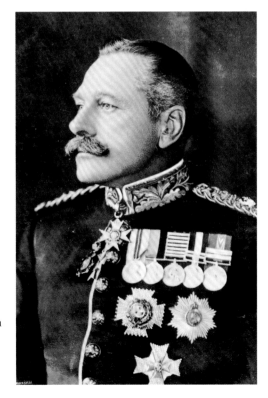

Sir Douglas Haig

In 1914, Field Marshall Douglas Haig,
assisting Field Marshall Sir John French,
organised the British Expeditionary Force,
which he took command of in 1915; a
position held until the war's end. Many claim
his poor leadership cost thousands of Allied
lives, while others argue the high casualty
rate was a reality of the type of warfare
being fought.

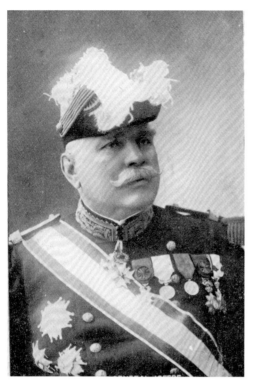

General Joffre

Marshal Joseph Jacques Césaire Joffre regrouped retreating French troops and defeated the Germans at the First Battle of the Marne in 1914. He was a popular leader, gaining the nickname 'Papa Joffre'. In February 1916, Joffre agreed with Haig on the Anglo-French offensive on the Somme. However, following high French losses, he was replaced by General Robert Neville on 13 December 1916. He became Marshal of France on 26 December 1916, a ceremonial role, and retired in 1919.

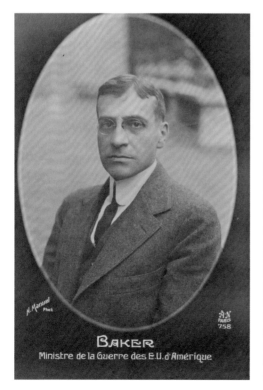

BAKER
Ministre de la Guerre des E.U. d'Amérique

Newton Diehl Baker,
Secretary of War for USA

Baker served as US President Wilson's Secretary of War from March 1916. His appointment surprised many, as early in his political career he expressed pacifist beliefs, but it was felt that Baker's views would be less confrontational than his aggressive predecessor, Lindley Garrison. He prepared the USA for war, and in 1917 appointed Pershing as Commander-in-Chief of the American Expeditionary Force. He was a member of the US delegation that travelled to Paris in 1919 and later, with Wilson, helped develop the League of Nations.

3

The Fighting Men

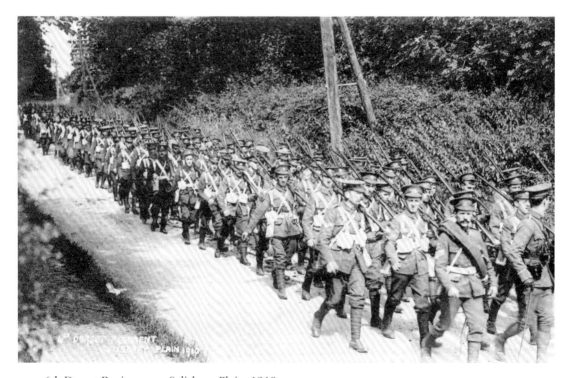

6th Dorset Regiment on Salisbury Plain, 1910

Prior to the outbreak of the war, Britain had maintained a large military force, which at the start of the war numbered around 400,000 men, a mix of the Regular Army and Reservists. The regular troops underwent constant training and numbers were maintained through new recruits. This Regular Army was the basis of the British Expeditionary Force (BEF) that entered mainland Europe after the declaration of war with Germany in August 1914. By the end of the war, the British Army contained around 4 million personnel.

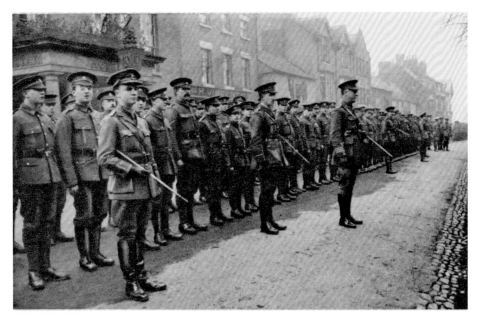

The 3rd Second Monmouth Parading at Oswestry, *c.* 1914
This postcard was issued to raise funds in aid of 'The National Fund for Welsh Troops'
and is typical of the images included on postcards of soldiers at the start of the war.

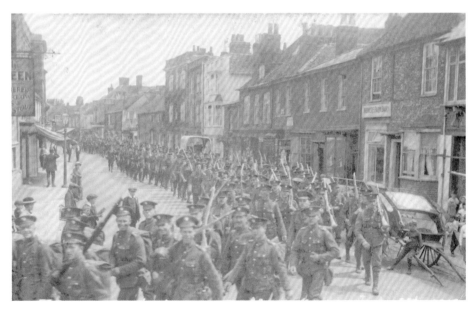

Troops Arriving in Marlow, 3 July 1915
Local photographers, more used to taking street scenes and portraits, began to record
the social changes being brought about by the war. This often included the militarisation
of the population, and saw many postcards being produced showing the mobilisation of
volunteers and the movement of troops.

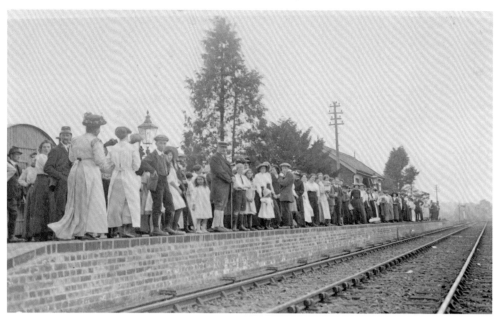

Volunteers Awaiting a Train at Ottery St Mary Station, Devon, 1 September 1914
Like many small towns in Britain, Ottery St Mary suffered a high loss of men, with eighty-seven being listed on the war monument inside the Parish church. Eighty-seven men might seem a small number but this was from a parish with a population of under 4,000.

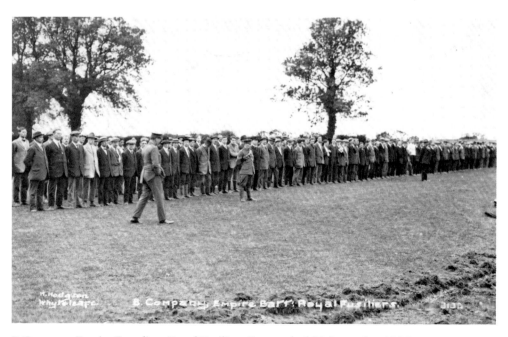

B Company Empire Battalion, Royal Fusiliers, Postmarked 23 September 1914
The volunteer recruits are on parade, still in their civilian clothing (*above*). This photograph was taken soon after the declaration of war, and the demand for uniforms and weapons was overwhelming.

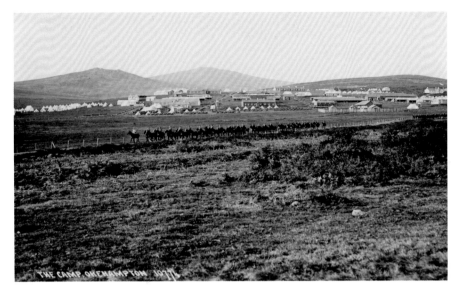

Military Camp at Okehampton, Devon, *c.* 1910

Okehampton Camp, established 1893/94, became the summer headquarters of the School of Gunnery and one of the most important practice camps in England. The camp was equipped with permanent and temporary accommodation, including stable blocks and gun stores. Pre-war military camps like this were quickly expanded to cater for the large numbers of new recruits.

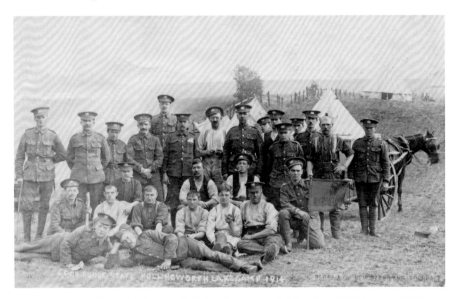

Cook House Staff at Hollingworth Lake Camp, Rochdale, Dated 27 August 1914

Hollingwood Lake was used as a temporary military camp. The *Rochdale Recorder* reported on 26 August 1914 that people watched from a distance as the order was given to 'strike camp' and the camp was packed up. Even though this was a training exercise, and the order was given for the camp to be set up again, some onlookers believed rumours that the camp was being dismantled as Germany was about to attack the south coast. The men would most likely have participated in this training.

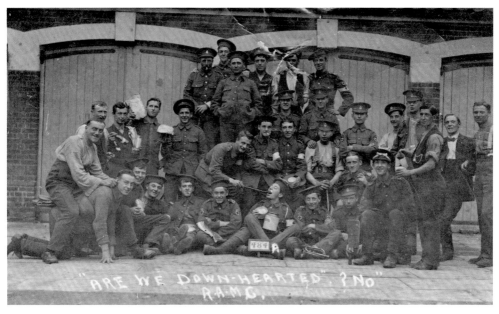

A Group From the Royal Army Medical Corps, 1914
This card was posted to Miss L. Blascel in Walthamstow, Essex, in 1914 from Jon, who writes a very short message stating 'this is how we enjoy ourselves'. This postcard and its message shows how upbeat the soldiers were at the start of the war.

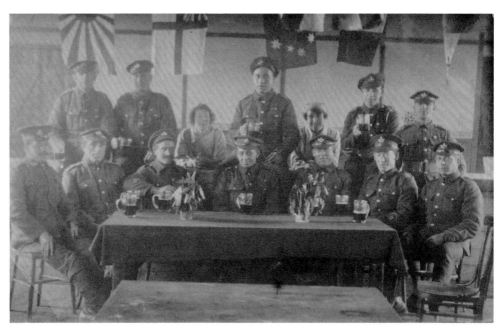

Soldiers From the Oxford and Bucks Light Infantry, With Female Canteen Workers
In the background are the flags of the Allied countries. With the large number of men joining up at the start of the war, providing sufficient food became a logistical nightmare, not only in finding the supplies, but also getting them to the camps and preparing the food.

Group of British Soldiers Relaxing With a Cat and Dog, Before Being Deployed
This typical group, showing young men with their caps at rakish angles, was popular at the start of the war before the horrors of what faced them in the trenches became known. It is likely these men knew each other and joined up together. Pals Battalions were common at the start of the war, but when small towns and villages lost most of their young men during a single campaign, the government stopped them.

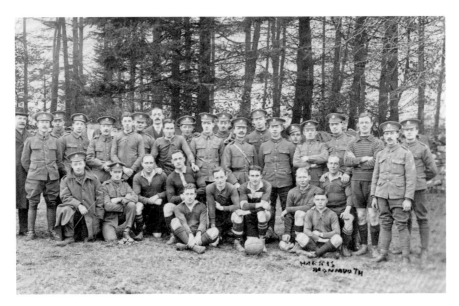

Troops Photographed in Monmouth
This postcard was produced in Monmouth, and unusually contains a mix of men in uniform and football kits. The date of the image is unknown, although it was posted in December 1918. If it depicts men at the beginning of the war, it could be a Pals Battalion made up from local sports teams, as there appears to be a range of football tops.

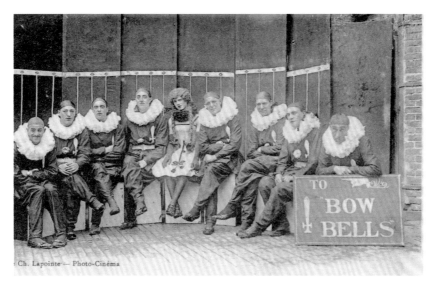

Ch. Lapointe — Photo-Cinéma

To Bow Bells Performance Group, 1916

Performance groups were important for morale. The message on this card to Molly Child in High Wycombe reads, 'Nov 1 1916. Dear Molly, a small party I went to the Bow Bells this evening, this is the anniversary of the regiments second year out here. I wonder how many more years the war will go on. I have not received a letter today from Blighty. Give my love to mamma and her new help + all the rest of the little helps. Daddy.'

HMS *Chester* Concert Party

It was common for fighting men to relax through parties. They were often well organised, as shown by the party on board the HMS *Chester*. Men on the front row can be seen dressed as 'Kaiser Bill' and Cartoonist Bairnsfather's 'Old Bill'. HMS *Chester* fought at the battle of Jutland, during which crew member sixteen-year-old Jack Cornwell won the Victoria Cross.

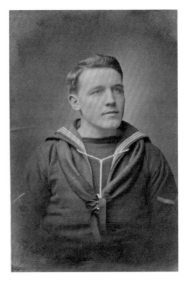
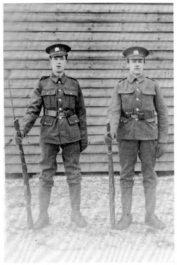

Top left: French and British Soldiers Toasting Each Other
It was clear early on that British and French troops generally didn't get on. However, through propaganda messages of this comradery (*above*), this dislike and distrust was not portrayed too widely.

Top right: Sailor, Photographed in a London Studio
On the reverse is the message 'To Auntie Annie from your loving Nephew Will April 17th 1916'.

Bottom left: 3rd Battalion Manchester Regiment C Company
This photograph was taken at Brockleby Camp, Warwickshire and one of the men is Pte C. Wright, 47753.

Bottom right: Photograph of Jack and George, Taken September 1914
Like many, this card only has the first names of the men being shown. Were Jack and George related, or just friends? Did they join up together and what happened to them?

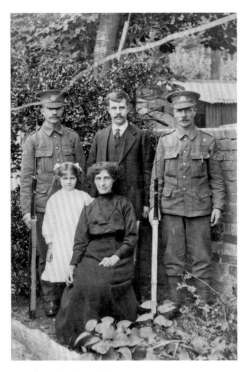
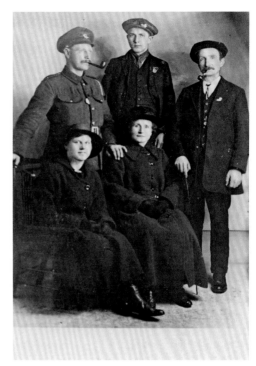

Unidentified Family Groups

In many postcards showing soldiers with families, the people depicted have become nameless and the family link has been lost. What is odd about the image on the left is that it clearly shows a family group in a domestic garden, but the two soldiers have their guns. The image on the right was taken by Wreathall & Wright of No. 44 Prospect Street Hull, and No. 43 Toll Gravel, Beverley, date-stamped 24 November 1917.

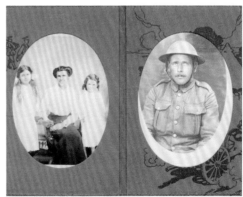

Military Folder to Hold Postcards

This thick paper folder has a First World War illustration on it. Inside are two apertures, through which postcard images can be seen. On the left is a British postcard of a woman with two children. On the right is a French postcard of a British soldier (her husband, and perhaps the children's father). As it is in such good condition, it is likely that this folder was a prized possession in Britain and held by the wife or family member.

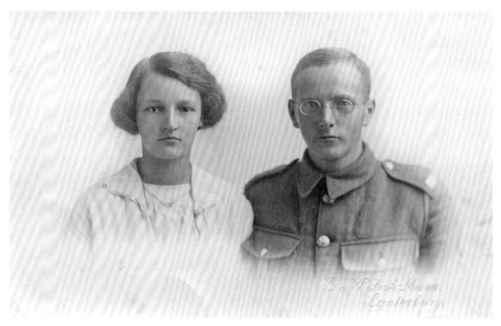

But I always write something silly, but excuse me this time, its "wartime" not "RAGTIME") I cannot think of anything else to say. So Hoping you are in the best of health and spirits at present (but then nurses always are) I remain Your sincere friend J. Leslie Gaved. Royal 1st Devon Yeomanry.

P.S. Do send your photo will you, I shall treasure it believe me.

Post Card

Correspondence

Devon writing

of course these may mean anything eh! Goodbye

Messages on Postcards

When looking at postcards, it is sometimes not the image that is important but the message on the back. The following message appears on a postcard of a normal English landscape and gives a personal insight: 'I always write something silly but excuse me this time, its wartime not "RAGTIME". I cannot think of anything else to say so hoping you are in the best of health and spirits at present (but then nurses always are). I remain your sincere friend J Leslie Gaved Royal 1st Devon Yeomanry. P.S. Do send your photo will you, I shall treasure it believe me. XXXXXXXXXXXX of course these may mean anything eh! Goodbye.'

Postcard of George Lionel Edwards, Possibly With His Wife or Sweetheart

This card was addressed to 'Bob' and was sent from Revd George Lionel Edwards of Ottery St Mary, Devon, with the message, 'in the Rough the smooth always friends'. The image was photographed in Canterbury, so it was possible George Lionel Edwards was based near there on training.

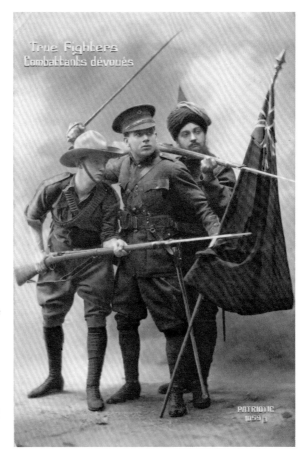

True Fighters (*Right*) and the Empire Flags (*Below*)

The patriotic card produced in France was posted to the UK in 1916 in acknowledgment of a package being received by a soldier (*above*). It shows a British, Australian and Indian soldier, and illustrates some of the British Empire representatives, as shown by the flags below.

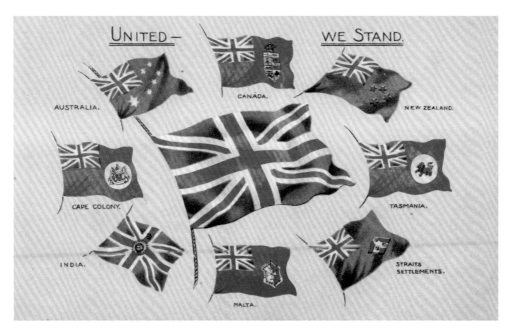

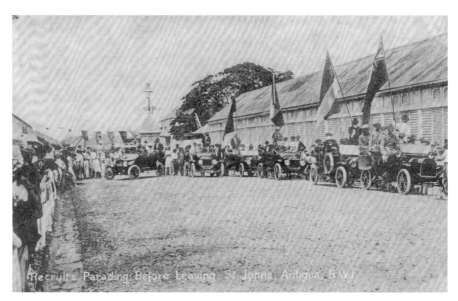

Recruits Parading in St John's, Antigua, in the Caribbean
Soldiers came from all over the British Empire. From the very small territories, Britain asked for financial support, rather than men, which meant many young Caribbean men paid their own passage to Britain to join up with British regiments.

New Zealand Troops at Sling Camp, Codford, Dated 28 April 1918
Large training and transfer camps were established at Codford, south of Salisbury Plain, for thousands of Australian and New Zealand (ANZAC) troops waiting to be deployed to France. Codford also became a depot in 1916 for men evacuated from the front line who were not fit to return. The message on the back reads, 'Dear Mum. Here is a photo of some of my hutmates at Codford. I have not come out very well as the light wasn't very good. The Corporal is a Military Medal man and they are all a decent lot of chaps. I am keeping well. Hoping you are all well, your loving son, Bert.'

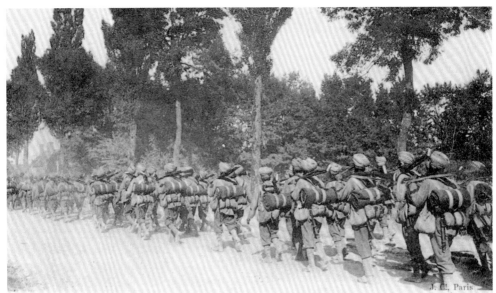

42. LA GUERRE de 1914 — Les Troupes Indiennes en France — Indian troops in France

Indian Troops in France, Postmarked 18 May 1915
Nearly 3 million personnel were mobilised from the British Empire, of which around 180,000 were killed. India supplied the largest number of men from the Empire, a total of around 1 million, of which 47,746 were killed or missing, and 65,126 wounded. At the outbreak of the war, the Indian Army had 155,000 men, and by the end of the war they numbered around 573,000.

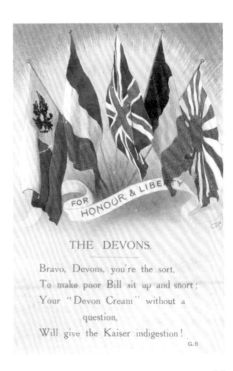

FOR HONOUR & LIBERTY

THE DEVONS.

Bravo, Devons, you're the sort,
To make poor Bill sit up and snort;
Your "Devon Cream" without a
 question,
Will give the Kaiser indigestion!

G.B

Regimental Honour
For many men there was great pride in the regiment they joined, stemming from the fact that the regiment represented the area of Britain they were from. Postcards were created that either celebrated the past achievements of the regiment, or a jingoistic verse promoting the regiment's involvement in the war, like this one for the Devonshire Regiment.

A Cavalry Sergeant from Kent, 'Cousin Joe Norman'
Michael Morpurgo's 1982 book *War Horse*, and subsequent movie and play, highlighted the horrors faced by horses. The war saw the last cavalry charge by the British Army, and trench warfare, barbed wire and machine guns made the horse, as a fighting weapon, obsolete. Most were used to move supplies (*see page 50*), guns and wounded soldiers (*see page 65*). Between 8 and 10 million horses took part in the war – 1 million from Britain. It was too expensive to bring them back home, so they were put down or sold to the locals, many being butchered for their meat.

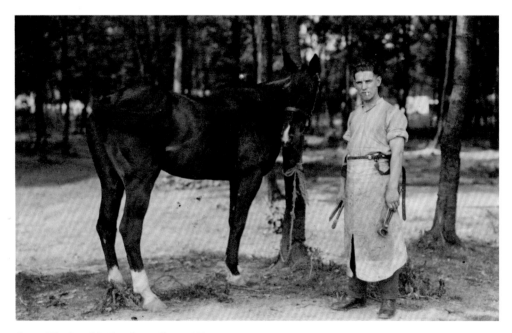

Army Blacksmith, Ready to Shoe a Horse
With the large numbers of horses being employed, blacksmiths were kept very busy.

4

The Battlefields

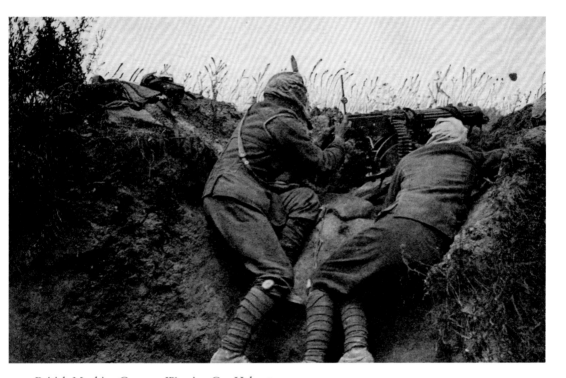

British Machine Gunners Wearing Gas Helmets
As the *Daily Mail* Series VIII No. 62 card states, 'war is no longer shell for shell and shot for shot. The unwounding, but deadly gas-cloud is added to the risks of the masked gunner'. This statement is untrue, as the gases not only killed soldiers on both sides but also left many with lung damage that often led to their death many years after the war had ended.

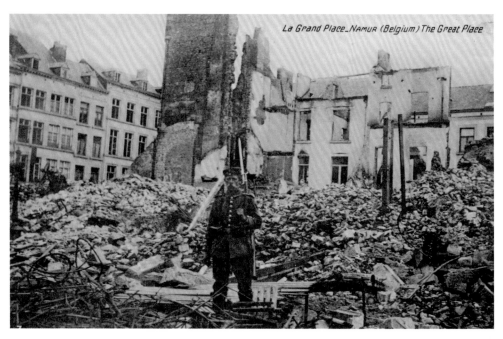

Great Place (*Above*) and Town Hall (*Below*) in Namur, Belgium

Following the fall of Liege on 16 August 1914, the Germans turned their attention to Namur. The garrison at Namur was small at only 37,000, compared to the 107,000 German troops, and was low in morale and ammunition. Namur had a series of forts built between 1888 and 1892, around 5 miles from the city centre, and attacks on the forts began on 21 August. By 23 August, Namur was close to collapse. Evacuation orders were given and the Germans took the town that evening.

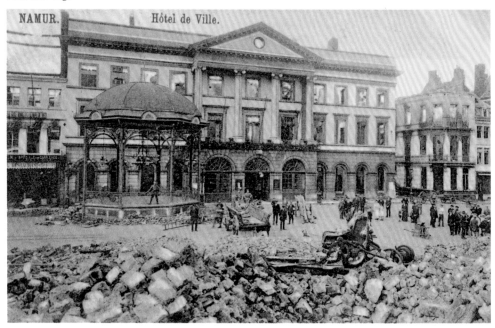

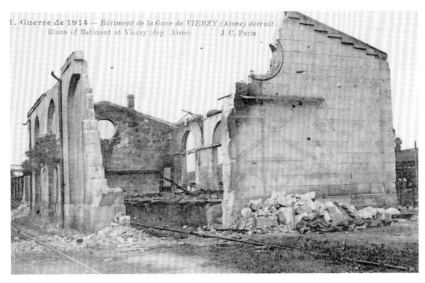

Ruins of Batiment at Vierzy, Following the First Battle of the Aisne
The First Battle of the Aisne saw Allied forces pursuing the retreating German Army following the First Battle of the Marne. The Germans halted their retreat at the River Aisne and set up defensive lines. On 13 September 1914, the Allied forces attacked and established a bridgehead, but counter-attacking Germans forced them back. A stalemate followed and fighting was abandoned on 28 September.

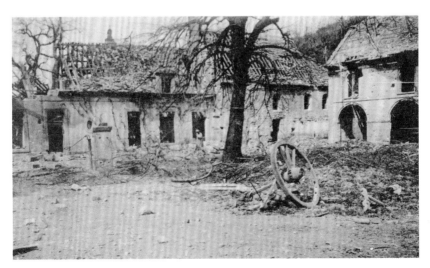

Ruins of the Interior of Ostel Castle, Probably Following the Second Battle of the Aisne (April–May 1917)
The Second Battle of the Aisne was a disaster for the French. It involved 12 million troops and was an attempt to break through the German lines in 48 hours. It was launched on 16 April 1917, along an 80 km front from Soissons to Reims, and saw 40,000 French casualties. The offensive was abandoned on 9 May, with 187, 000 French and 168,000 German casualties.

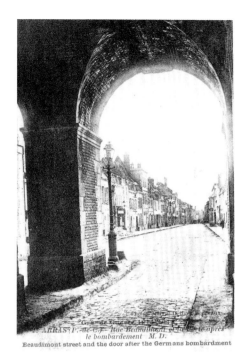

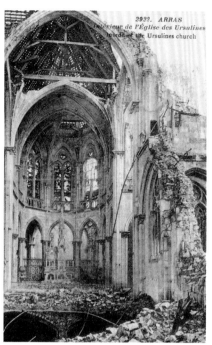

Rue Beaudimont (*Above Left*) and Interior of the Ursulines Church, Arras (*Above Right*), Following the First Battle of Arras

The first Battle of Arras, started on 1 October 1914, was an attempt by the French to outflank the German forces along a line between Arras and Lens. Initially the French progressed, but a German counter-attack saw French troops being withdrawn. The French managed to hold onto Arras, though faced with heavy German attacks, but nearby Lens was taken by the Germans.

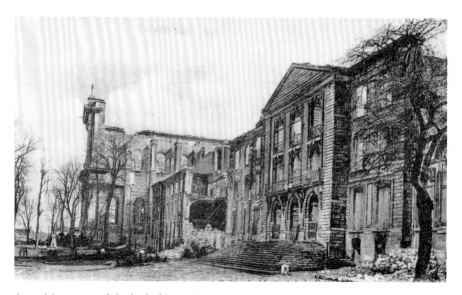

Arras Museum and Cathedral in Ruins

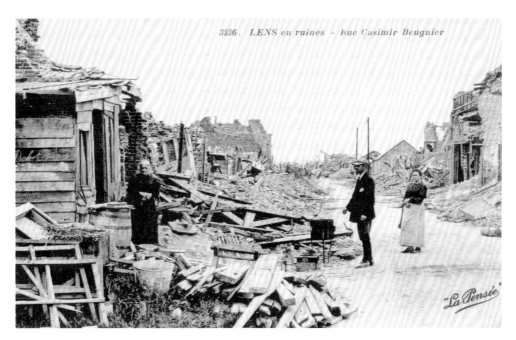

Rue Casimir Beugnier, Lens
While Arras didn't fall, Lens fell into German hands on 4 October 1914. The town was heavily devastated by the fighting, with residents forced to flee their homes.

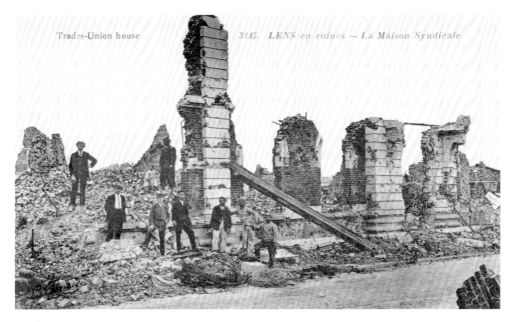

Trades Union House, Lens
Much of Lens lay in ruins, and was held by the Germans until their final retreat at the end of the war. However, in August 1917, Canadian forces advanced on the town in an attempt to retake it. Brutal hand-to-hand fighting ensued, but the Allied forces were forced back with the majority of attackers killed, wounded or captured.

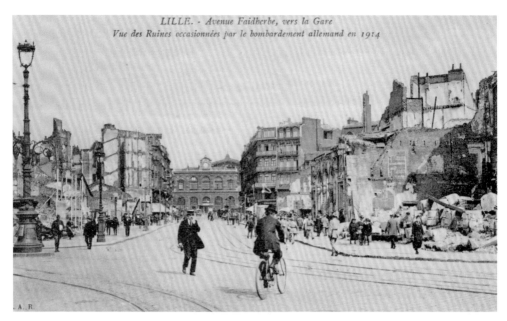

LILLE. - Avenue Faidherbe, vers la Gare
Vue des Ruines occasionnées par le bombardement allemand en 1914

Avenue Faidherbe, Lille, After German Bombardment, 1914
Lille is the largest city in French Flanders. At the start of the war Lille was poorly defended, but the city held out from 4 to 13 October 1914, during which over 2,200 buildings were destroyed. The Germans then occupied the town, until it was liberated by the British on 17 October 1918.

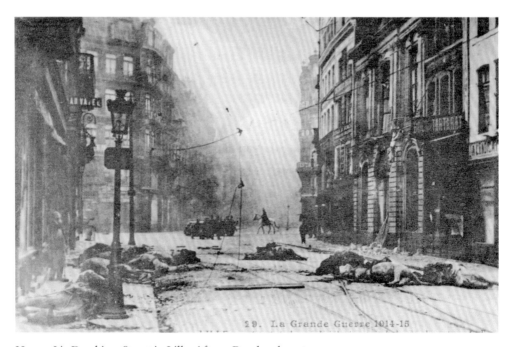

29. La Grande Guerre 1914-15

Horses Lie Dead in a Street in Lille, After a Bombardment
Even though this card clearly shows scenes from the 1914 bombardment, the card states the Great War 1914–15, which means it must have been produced in 1915.

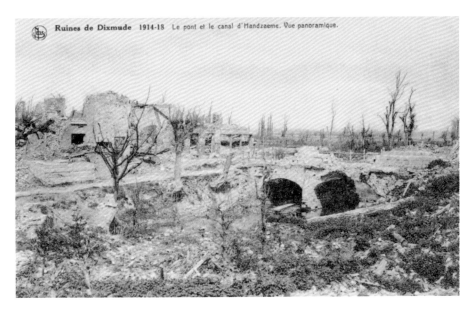

Ruins at Dixmude

The first phase of the German Flanders Offensive, starting 20 October 1914, was to advance and take Dunkirk, Calais and Boulogne. Belgium forces retreated, and the Germans soon held a 20-mile-long strip of land between Dixmude and Nieuport. On 27 October, King Albert ordered the sluices to be opened and flooded the land between the Belgian and German forces. The Germans were halted, so they started the second phase of the Flanders Offensive by attacking Ypres. The postcard was produced as part of the *Service des Sites de la Guerre 1914–18*, sold to raise funds for people injured, and children left orphaned, by the war (*above*).

Trenches Near Nieuport, Belgium, 1914/15

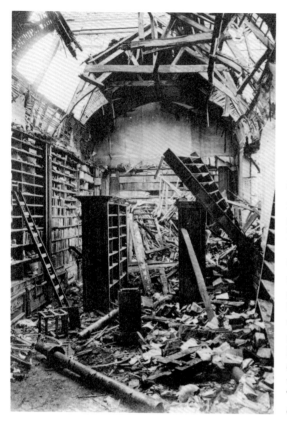

Library in Ypres, Damaged in the First Battle of Ypres, 1914
The importance of Ypres is reflected in the five major battles that occurred around it during the war. During the First Battle of Ypres, started 14 October 1914, the Allies halted the German Army's advance to the east of the city. The German Army eventually surrounded the city on three sides, bombarding it throughout much of the war. The Second Battle of Ypres marked another German attempt to take the city in April 1915. The third battle in 1917, commonly referred to as Passchendaele, was a complex five-month engagement. The fourth and fifth battles occurred during 1918.

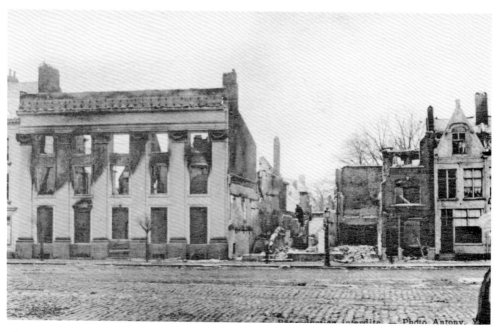

Place Vandenpeereboom, Ypres, Damaged in the First Battle of Ypres, 1914

Ypres, Most Likely After the Second Battle of Ypres, 1915

The Second Battle of Ypres, beginning 22 April, was the only major attack led by the Germans on the Western Front in 1915, and attempted to divert Allied attention from the Eastern Front. On 22 April, it became the first battle on the Western Front to use chlorine gas. The gas affected 10,000 troops, half of whom died, with 2,000 captured. Allied forces repelled a second German advance following a gas attack on 24 April. As German troops were unable to take the town, they decided to try and demolish it through bombardment. Ypres was rebuilt in the 1950s.

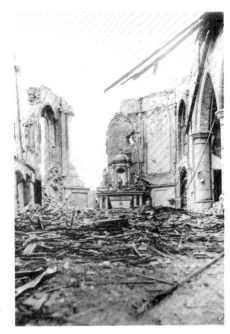

Interior of the Ruins of St Julien Church, Langemark, Belgium, 1915

Throughout October and November 1914, Langemark was the scene of heavy fighting. Following the first gas attack on the Western Front in April 1915, the Germans took the town and held it until the British took it back in August 1917.

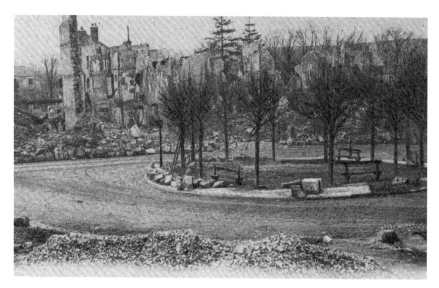

'Place d'Armes' After the Bombardment, Verdun

The German siege of Verdun was the longest battle of the war. Germany felt that if France was defeated in a major battle, Britain would seek peace. Verdun was chosen for symbolic rather than strategic reasons. The siege of Verdun began on 21 February 1916, nine days late due to bad weather, which allowed French reinforcements to be brought in. Even so, the 200,000 defenders were outnumbered by 1 million Germans. The first day of bombardment saw 100,000 shells land on Verdun every hour. Fierce fighting in the first few days saw outlying French trenches fall, but Verdun, with intact supply routes, stood resolutely. The battle continued until December 1916, with no tactical advantage being gained by either side, but both suffering major losses of men.

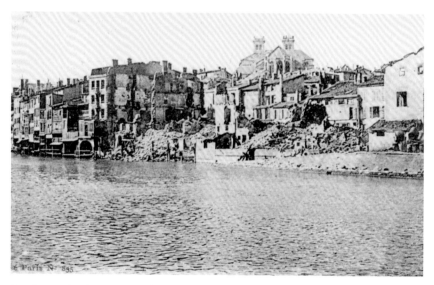

On the Bank of Meuse, Verdun

This district suffered a bombardment of incendiary shells. In the background is the cathedral.

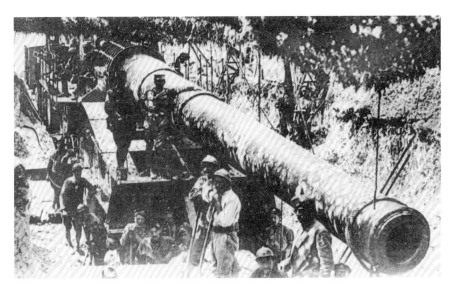

French Large Canon, Under Camouflage on the Somme
It is no wonder there was such carnage when guns of these size were used. On the first day of the Battle of the Somme, 1 July 1916, the British Army had nearly 60,000 casualties, of which over 19,000 were killed. The French Army had 1,590 casualties and the German 2nd Army had over 10,000 losses. The total number of casualties for the Battle of the Somme are disputed, but are in the region of 620,000 Allied casualties, with around 150,000 being killed or missing, and 465,000 German casualties of whom around 165,000 were killed.

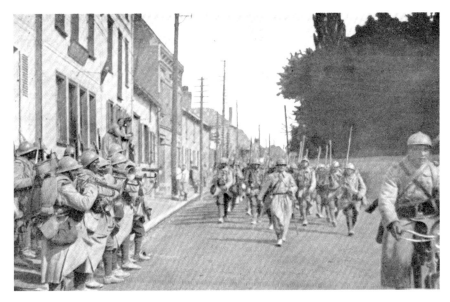

French Infantry, Marching to the Somme Trenches
This card was part of the series issued by Newspaper Illustrations Ltd, which were the official photographs of *Le Section Photographique de l'Armee Francais*.

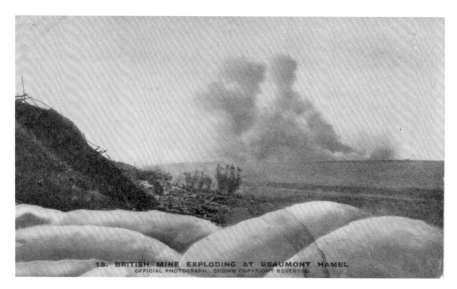

British Mine Explosion at Beaumont Hamel, Battle of the Somme
The image is from the *Daily Mail* Series II No. 13, and illustrates the devastation that a single explosion could cause.

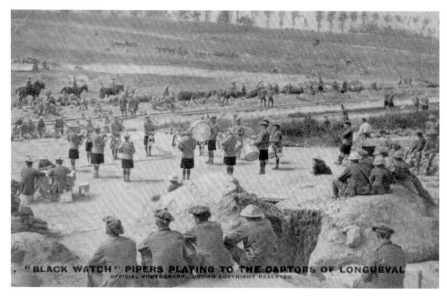

The Black Watch Pipers Playing to the Captors of Longueval, Battle of the Somme
As the *Daily Mail* Series III No. 21 card states, 'The Tommies who are seen listening to the Black Watch Pipers, had just been engaged in the storming of Longueval, which they took in 25 minutes'. This was not accurate. On 14 July 1916, Allied forces advanced on German lines. The attack went well, but then developed into house to house fighting and the Highlanders took considerable fire from the nearby Delville Wood. By the afternoon, large parts of the town were in Allied hands. On 15 July, instructions were given to take the Delville woods at all cost. The wood was finally taken on 26 July, but a counter-attack by the Germans meant that they were not finally driven out until 3 September.

Safe in the Basement of the Tiguet Bank
After the Bombardment, Bapaume
In 1916, Bapaume was one of the
objectives in the battle of the Somme.
In 1918, between 21 August and
3 September, Bapaume was part of the
second phase of the Battle of Amiens.
On 29 August, New Zealand and
British troops occupied the town after
heavy fighting.

Placing Underground Telephone Line in a Village, During the Battle of the Somme

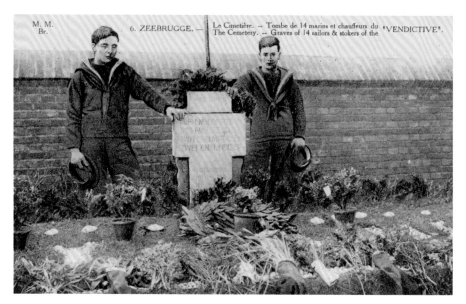

M. M.
Br.

6. ZEEBRUGGE. —

Le Cimetière. -- Tombe de 14 marins et chauffeurs du "VENDICTIVE".
The Cemetery. -- Graves of 14 sailors & stokers of the "VENDICTIVE".

The Graves of Fourteen Sailors and Stokers of the *Vindictive*, Zeebrugge

Zeebrugge was an important German submarine base. Seventy-five Allied ships took part in a raid, starting on 23 April 1918. HMS *Vindictive* provided cover during the operation to sink old war ships, to block the channel and prevent German U-Boats accessing the North Sea. HMS *Vindictive* landed 200 soldiers to destroy the German batteries, but heavy fire damaged the ship's guns. Allied fatalities totalled around 200. Eight Victoria Crosses were awarded, one to the captain of *Vindictive*, Admiral Carpenter. The attack on Zeebrugge and Ostend failed to meet their objectives, and did little damage to the German submarine ability.

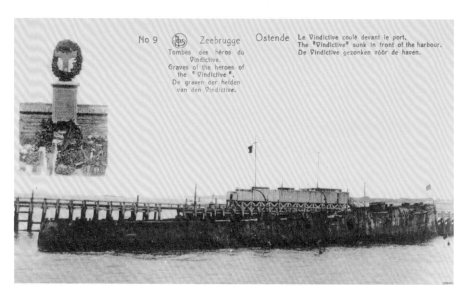

The Wreck of the HMS *Vindictive*, Lying at the Entrance to Ostend Harbour

The inset in the top left is a memorial to HMS *Vindictive* crew, who died during the raid on Zeebrugge.

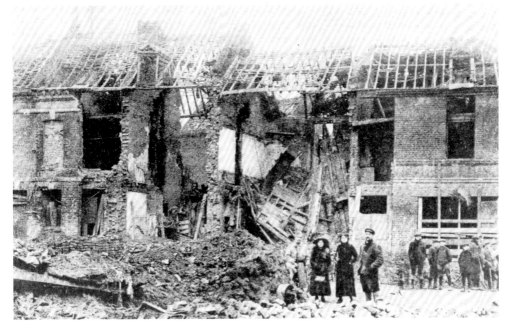

Ruins (*Above*), and Rue de Beauvais (*Below*) in Amiens

Amiens was captured by the Germans on 31 August 1914, recaptured by the French on 28 September 1914, and became an important rail hub for the Allies. The German Spring Offensive, launched on 27 March 1918, listed the capture of Amiens as a priority. The Germans soon held nearby high ground and bombarded Amiens, destroying over 2,000 buildings. The Battle of Amiens on 8 April saw an Allied counter-attack and was the start of the final phase of the war, later known as the Hundred Day Offensive. The German offensive stalled and Allied forces advanced.

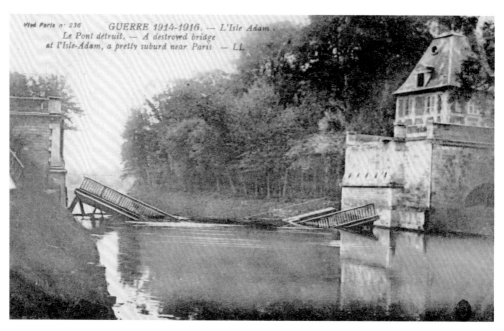

Ruins of a Bridge at L'Isle Adam, a Suburb Near Paris, 1916
It was important to restrict the movement of soldiers so both sides would take out strategic targets such as bridges and railway lines.

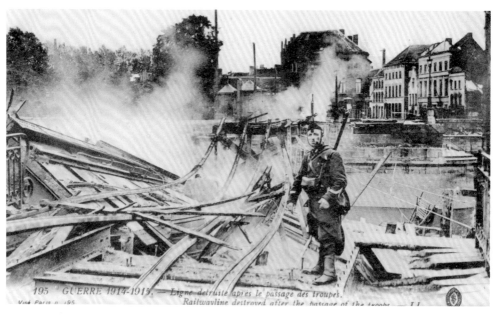

A Railway Line Destroyed After Passage of Troops, 1914/15
Unusually, this picture has no location. Was that deemed too sensitive and needed censorship?

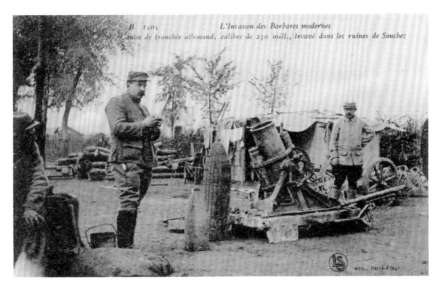

Captured German 250 mm Canon, Found at the Ruins of Souchez
Souchez is a village around 2 miles north of Arras. It was seized by German forces in 1914 and held the area as they controlled the two ridges, Vimy Ridge and Notre Dame de Lorette, which flanked the village. In the autumn of 1915, the French captured the high ground at Lorette and, in March, handed control to the Commonwealth Forces.

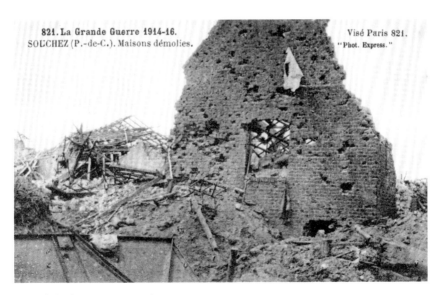

Demolished House in Souchez, 1916
The Battle of Vimy Ridge was part of the opening phase of the Second Battle of Arras in April 1917. The Canadians captured most of the ridge on the first day, but over the first four days, 3,500 men were killed. The Allies suffered around 160,000 casualties and the Germans around 130,000. Outside Souchez is the Cabaret-Rouge British Cemetery, named after a café on the site that was destroyed by bombing in 1915. The cemetery holds over 7,650 commonwealth burials.

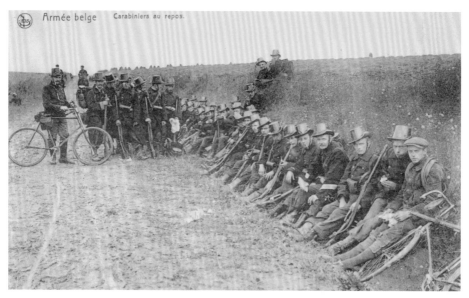

Belgian Army at Rest

At the start of the war, the Belgian Army tried to resist the invading Germans but was soon overpowered by superior forces. During the war, Belgium mobilised nearly 300,000 troops, of which 38,000 were killed fighting alongside the Allied troops.

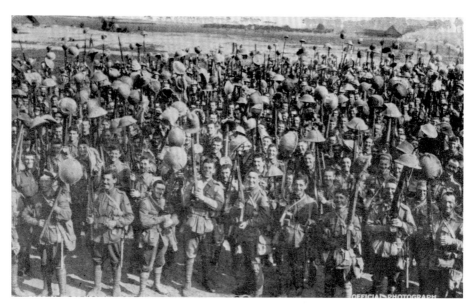

Australians Parading for the Trenches, *Daily Mail* Battle Pictures Series X No. 80

Around 60,000 Australians were killed during the war, and a further 150,000 were wounded. Australian forces started the war in campaigns in German New Guinea, and in German possessions throughout the Pacific. They were then shipped to Egypt, and in 1915 went to fight in the trenches of Gallipoli in the Ottoman Empire. In 1916, the Australian Army was withdrawn from Gallipoli and served on the Western Front.

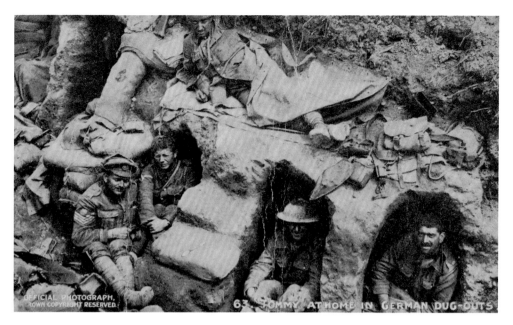

A Tommy at Home in a German Dugout
As the *Daily Mail* Series VIII No. 63 card states, 'Our Tommies soon make themselves at home in the German dug-outs, when they have driven out their tenants with shell, bomb and bayonet'. Any type of shelter was welcome, but in truth offered little protection from either enemy fire or the elements.

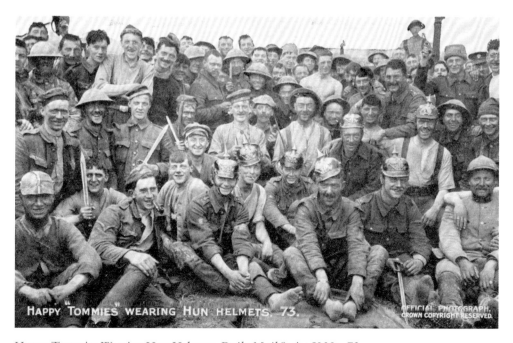

Happy Tommies Wearing Hun Helmets, *Daily Mail* Series X No. 73
This image illustrates the fact that British troops collected mementos such as German helmets, bayonets and daggers from the captured trenches and prisoners of war.

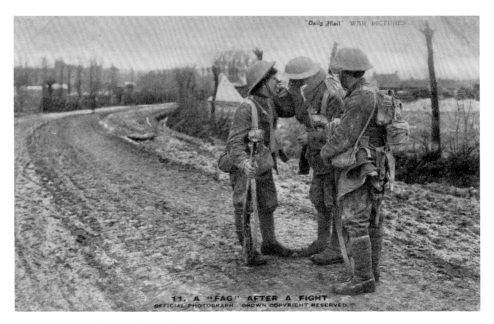

A Fag After a Fight, *Daily Mail* Series II No. 11

Smoking was a popular pastime, but for many soldiers it became a necessity in the trenches. Cigarette smoke not only masked the stench, of rotting bodies and animals, but also helped keep flies away from the soldiers' faces.

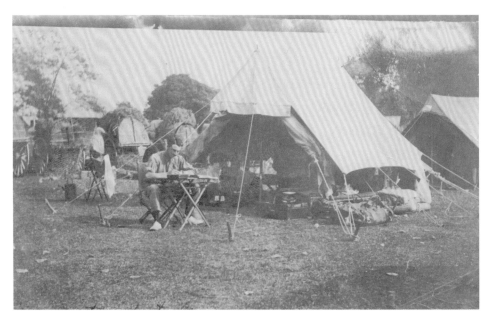

Transport Lines

One of the most important things in the trenches were the communication lines, not only because troops could receive orders but, more importantly, so that they could receive weapons, ammunition and supplies of food. Behind this soldier writing (maybe writing home or making an inventory) is a line of carts used to carry supplies.

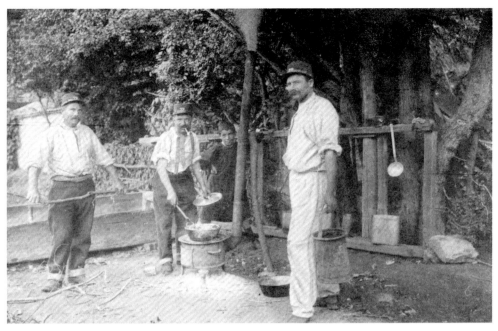

The Mess (*La Popote*)
Providing food for the troops was often very difficult. With limited supplies, the soldiers had to be inventive about where and how they cooked their food.

Mobile Chapel of the Belgian Army
With the soldiers constantly on the move, everyday activities had to be brought to them wherever they were. This not only included the essentials of military supplies, clothing and food, but also the means to meet their spiritual needs.

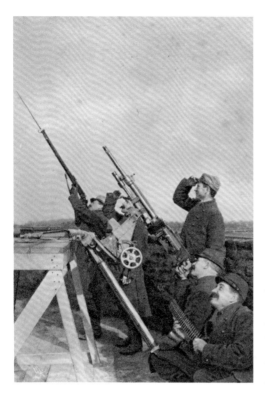

French Soldiers on Lookout for Planes,
Tuck's Postcard No. 4,318
One of the technological advances seen in
the war was the use of aircraft. Planes were
used to record enemy trenches and troop
movement, to drop bombs on enemy targets
and to protect ground troops from aerial
attack. Soldiers now had to develop new
techniques to shoot down these
moving targets.

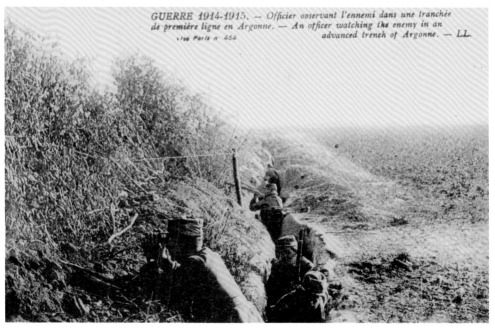

French Officer, Watching the Enemy in an Advanced Trench at Argonne, 1915
The Argonne was a densely wooded area, famous for the Meuse–Argonne Offensive in 1918, as
part of the final Allied advance, with of 1.2 million American soldiers participating. This card
dates from 1915, at which time the Germans had dug in at Argonne.

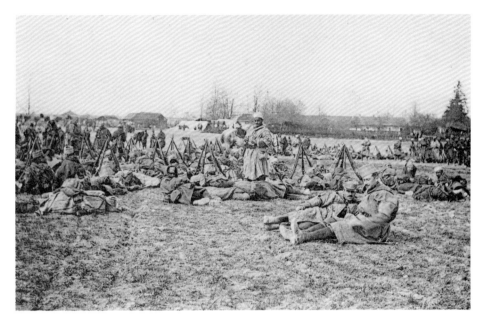

Resting Place Near Souain, 1914/15
In September 1915, Allied forces assaulted German positions in Souain during the Battle of Champagne. They took the area, but with great loss of life. On 9 December 1915, the Souain battlefield, which had remains of trenches and rough terrain, became the testing place for a prototype armoured vehicle motorised with a Holt Baby caterpillar. It is unclear if the troops pictured are about to take part in the September battle, or the tank test in December.

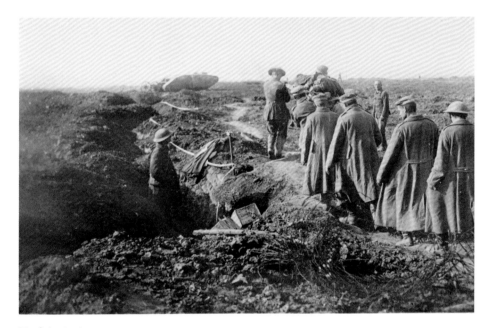

Tank in Action
This postcard is one of the *Daily Mirror* Canadian Official Series, and shows a tank in the background going over a trench. In the foreground, German prisoners are being moved.

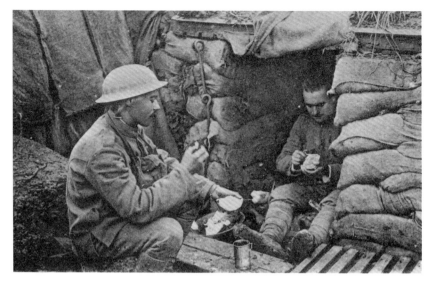

Portuguese Troops Having Lunch in the Trenches
At the beginning of the war, even though it had an alliance with Britain, Portugal stayed neutral. When Germany blockaded Britain, an important trade partner of Portugal, Portugal suffered. Tensions with Germany worsened with clashes in Portuguese Angola. Germany declared war on Portugal in 1916, and in July 1916 the Portuguese Expeditionary Force was established. It deployed 55,000 men to the frontline. Around 7,000 Portuguese men, and Africans from their colonies, were killed in action.

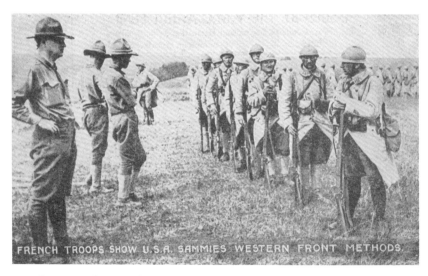

French Troops Showing the USA 'Sammies' Their Western Front Methods
This is one of the cards issued by the YMCA Hut Fund in the USA. The YMCA not only raised funds to help the troops, but also provided accommodation to troops returning home, or on leave, and, as the card's reverse states, 'to provide comforts, shelter and recreation for our Soldiers'. In total, the series contained 312 cards.

Greek Soldiers in Training on Salonika, 1916
Greece formally entered the war in 1917, but had moved forces into southern Albania, which it claimed was theirs in 1914. Salonika was transformed into a Franco–British military area from 1915, after their withdrawal from Gallipoli, and former Greek Prime Minister, Eleftherios Venizelos, set up a rival government in Salonika. When King Constantine (brother in law of Kaiser Wilhelm II) abdicated in 1917, Venizelos assumed control of the country and Greece entered the war alongside the Allies.

A Captured German Trench
An effective propaganda story was the capture of enemy trenches and weapons. Therefore, postcards like this were very popular. Interestingly, the captured German trench card states that the 'Wire [was] not destroyed', suggesting that the Germans abandoned the trench, rather than it being taken by Allied force.

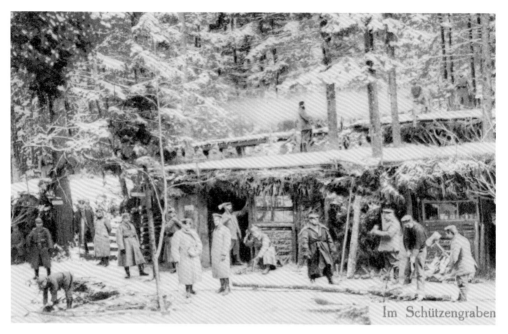

German Trenches
Not all the trenches were like the commonly depicted mud-filled holes. Some of them were more elaborate, like this German base in woodland.

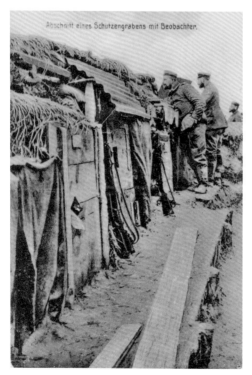

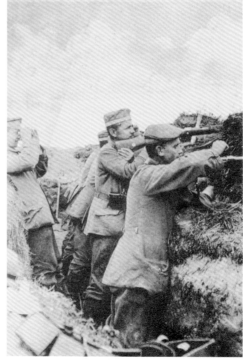

German Observer (*Left*) and German Troops in the Trenches (*Right*)

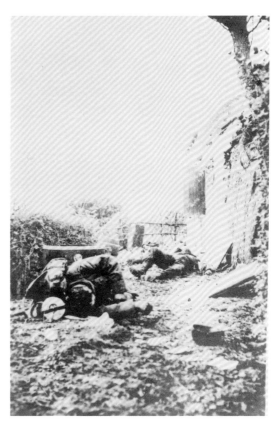

German Postcard Showing Dead Allied Soldiers

One interesting aspect of nearly all postcards produced is the lack of dead bodies depicted. Where they are depicted, they generally only show dead enemies. In the British postcard below, a German soldier lies dead in the background. In the German postcard to the right, Allied troops lie dead.

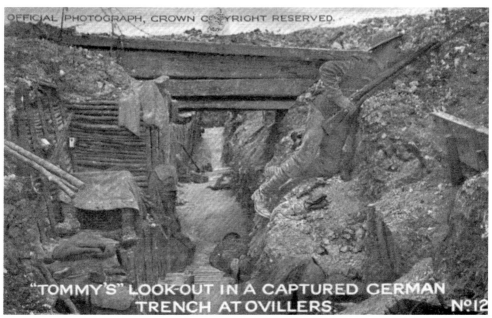

A Tommy in a Captured German Trench at Ovillers, With a Dead German on the Floor

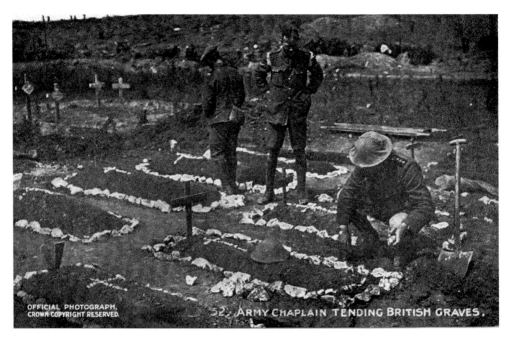

OFFICIAL PHOTOGRAPH.
CROWN COPYRIGHT RESERVED.

52. ARMY CHAPLAIN TENDING BRITISH GRAVES.

Army Chaplain Tending British Graves

Postcards like these attempted to show that the fallen soldiers were treated with respect and formally buried. However, for many, this was not true. Many who died in no man's land were left there, and remained unburied, or the manner in which they were killed often left little or no remains.

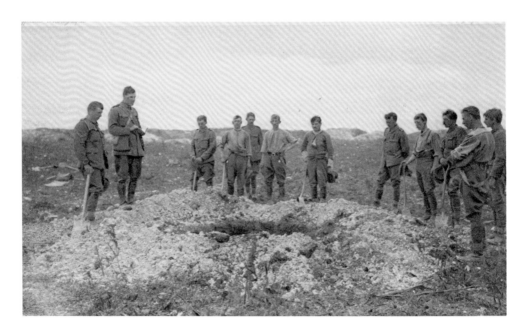

5

Prisoners of War

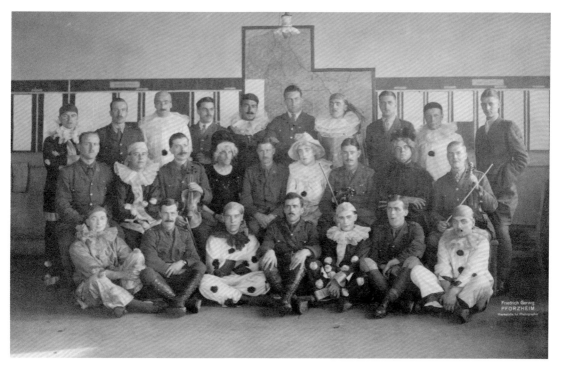

British Prisoners of War at Pforzheim
Pforzheim is a small town in south-west Germany, at the edge of the Black Forest. During the war they lost around 1,600 people in the fighting. For a short while in 1918, an *Offizierlager* (officer's camp) was developed to house Allied POW officers. As the picture shows, to ease boredom in the camps, entertainment such as concert parties were organised. A local photographer, Friedrich Gerwig, captured the moment.

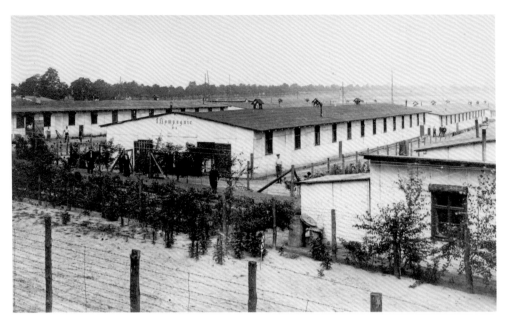

Unidentified German Camp for British Prisoners of War
With so many men fighting, it was inevitable that large numbers on both sides were taken captive. Generally, both sides tried to treat prisoners humanely. An estimated 2.4 million Allied prisoners were held in Germany.

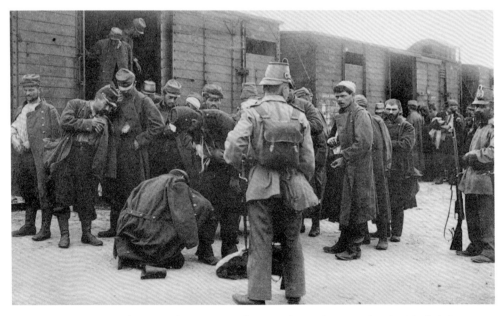

German Soldiers Guarding French Prisoners of War at the Railway Station in Ohrdruf, Germany
The prisoner of war camp at Ohrdruf was located at a former army training ground and held 15,000 prisoners. It was a camp for private soldiers and officers, known in German as *Mannschaftslager* (enlisted men's camp).

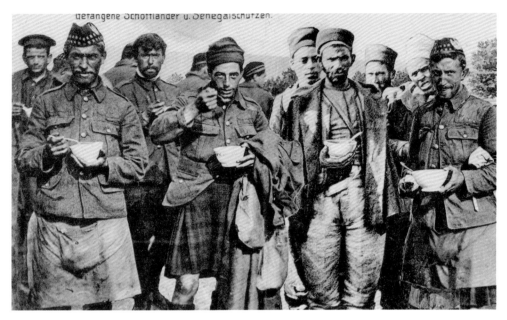

Captured Scottish and French Prisoners of War

A major propaganda coup was being able to photograph prisoners of war, especially showing them to be fit and being looked after, such as being supplied with food.

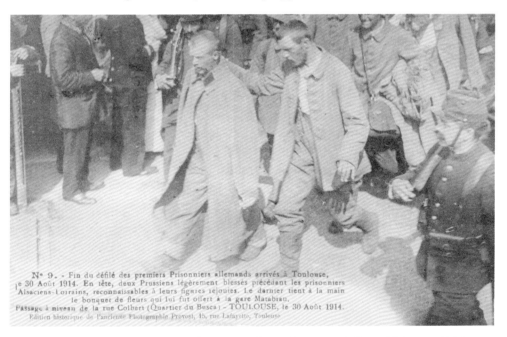

First German Prisoners Arrive at Toulouse, Marching Along Rue Colbert, 30 August 1914

During the war, around 8 million men were held in prisoner of war camps. The largest portion was 3.3 million captured Russians. Russia held 2.9 million prisoners, and Britain and France held 720,000 – the majority of which were taken prisoner just before the Armistice. The USA held around 48,000.

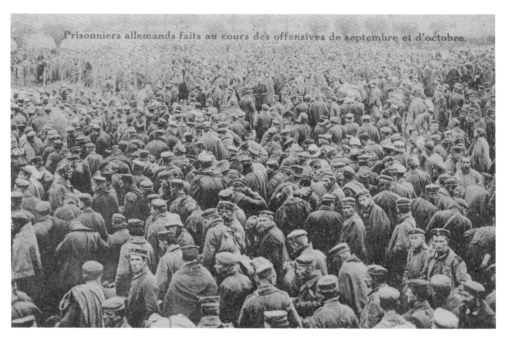

Captured German Prisoners, During the September and October Offensive
The caption states that these are German prisoners captured during the offensive in September and October. The numbers shown must mean it is 1918, during the final months of the war, as the Allied forces overran German positions.

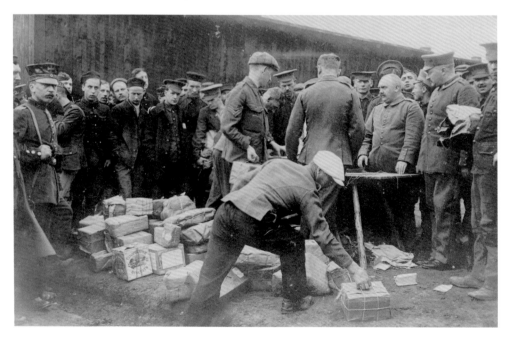

Distribution of Red Cross Supplies to Prisoners of War
British workers are distributing supplies to captured German troops.

6

Wounded Soldiers

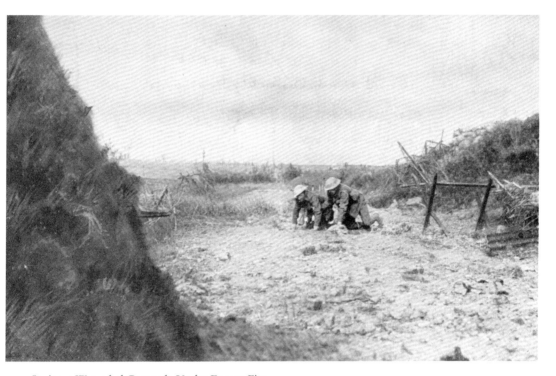

Saving a Wounded Comrade Under Enemy Fire
This propaganda postcard was No. 24 in the *Daily Mail* Official War Photographs Series
III. It is most likely showing a staged event. Many soldiers would have died from wounds in
no man's land, as they were unable to get back to the safety of their trenches for treatment.
Many first-aiders and stretcher parties entered direct fire, risking their own lives, to save
wounded comrades.

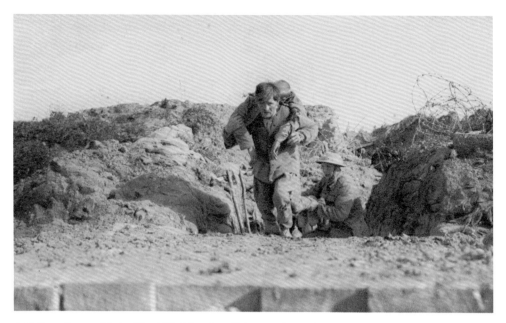

A Gallant Rescue Under Fire: This Man Saved Twenty Lives Like This, *Daily Mail* Series IV No. 30
The text on the card tries to capture the tension and heroics, by adding the text that, 'for the man who is carrying a wounded comrade on his back is actually under fire'.

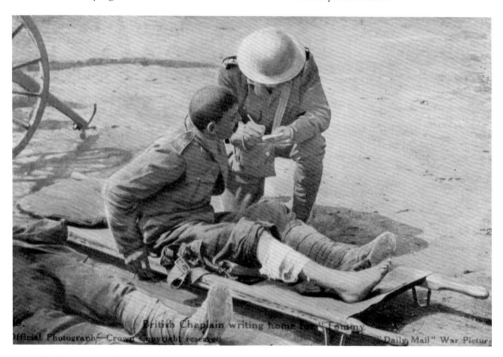

British Chaplain Writing a Letter Home for a Wounded Tommy
This card was issued as No. 99 in the *Daily Mail* Series XIII. The card states that writing letters for wounded soldiers on the battlefield was one of the unofficial tasks of the padre.

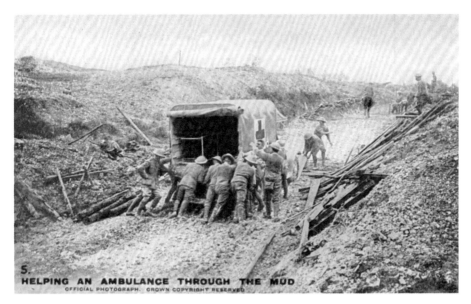

HELPING AN AMBULANCE THROUGH THE MUD
OFFICIAL PHOTOGRAPH. CROWN COPYRIGHT RESERVED

Helping an Ambulance Through the Mud, *Daily Mail* Series I No. 5
Even when in comparative safety, wounded men faced severe tests getting from the front to an area where they could be safely treated. It often meant that they might still be under fire, or the muddy conditions made it a painful if not deadly journey.

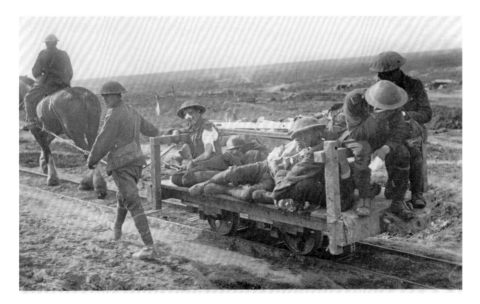

Wounded Returning to the Dressing Station After an Attack
This postcard is one of the *Daily Mirror* Canadian Official Series. Like many postcards depicting injured men, these appear to be the walking wounded, who had lesser injuries. The men are being carried on a railway line used to move supplies to the front, and the wounded to the first aid stations. Horses provided the pulling power for the carts.

Wounded Returning to a Dressing Station After an Attack
This official war photograph postcard maintains the tradition of only showing the walking wounded, trying to hide the fact that many soldiers were so seriously wounded that they needed to be carried from the battlefield.

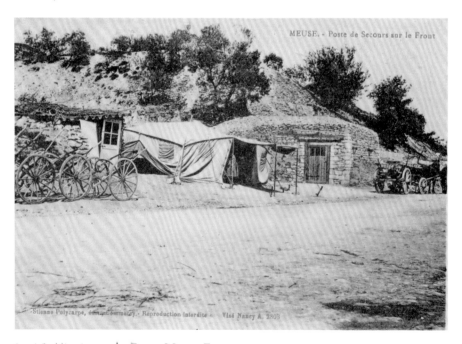

First Aid Station at the Front, Meuse, France
Through the twentieth and twenty-first centuries, first aid on the battlefield has improved dramatically. However, the First World War was fought before the discovery of penicillin, and there were few effective pain controls. Soldiers often died waiting to be treated, and the first aid was almost primitive compared to that available in today's battlefields.

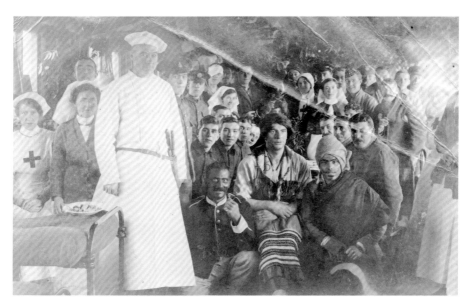

Injured British Soldiers in a Military Hospital

For some, the road to recovery was very long. Hospital staff tried to create an environment where soldiers felt comfortable, where more 'normal' activities could take place, as illustrated by the fancy dress in the postcard.

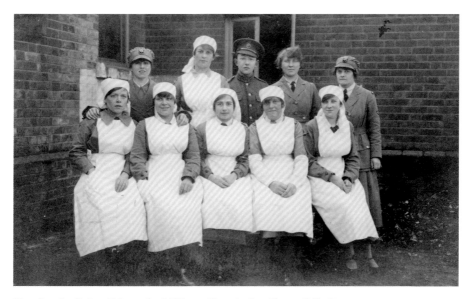

Nursing Staff, Possibly at the Military Hospital at Shorncliffe Camp

Shorncliffe Camp near Folkestone, Kent, was a military training camp used by the Canadian Army during the First World War. The Canadian Army Medical Corp operated its general hospital No. 9 at Shorncliffe from September 1917 until December 1918, and its general hospital No. 11 from September 1917 until September 1919. This card probably shows nurses and medical staff who worked there, as written on the reverse is Ross Barracks, Shorncliffe, which was part of the Shorncliffe Camp.

Convalescing Soldiers in the UK

The First World War was the first time that the British public got to see large numbers of men ,seriously disfigured in the fighting, with lost limbs (*see next page*), burns and serious scarring, as well as those suffering psychological damage. Convalescing soldiers were issued a suit of blue cloth, known as 'hospital blues', and provided them with a visible badge of honour. The convalescing soldier could wear his own khaki service cap bearing his regimental badge.

Message Home From an Injured Soldier

One type of postcard rarely discussed is the French risqué image. These showed women in stages of undress, often fully nude. They were illegal to send, so soldiers often just kept them to themselves. This oddity shows a postcard from the start of a risqué sequence (a later card probably showed this woman at least topless) and was sent to Miss Gladys Gamble by Col. Black, informing her he was recovering from shrapnel injuries in the Reading War Hospital.

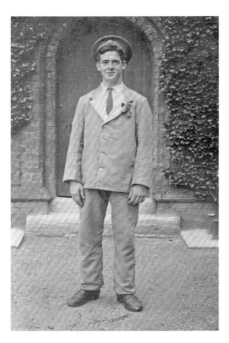
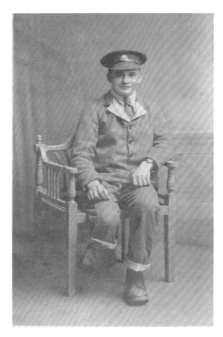

Portrait Postcards of Injured Service Men

Many injured men sent photographs to loved ones. The images, now mostly anonymous, often show ill-fitting 'hospital blues' and their injuries, such as the man with an amputated leg (*above*). They also show regimental caps, for example the man (*below right*) wears a Welsh Regiment cap. The image on the left (*below*) was sent to No. 184, Great Western Street, Moss Side, Manchester and the message reads: 'Dear Gladys + Lionel, I thought you would like this card of Willie. He is in England but getting better nicely. I've been to see him this weekend. Am in M/C now & will be to see you some day. Hope you are quite alright. Much love to both, Alice and Willie.' It is likely that Alice is Willie's wife.

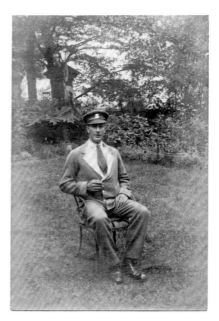

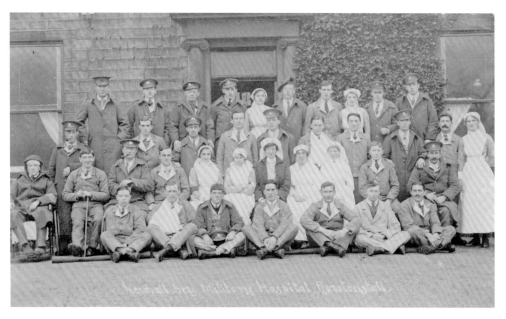

Staff and Patients, at New Hall Hey House Military Hospital, Rawtenstall, Lancashire
The message on the reverse of this card reads, 'From George with Best Wishes 7/12/16'. Many of the hospitals that convalescing troops were sent to were adapted public buildings, and others were large private houses with space enough for wards.

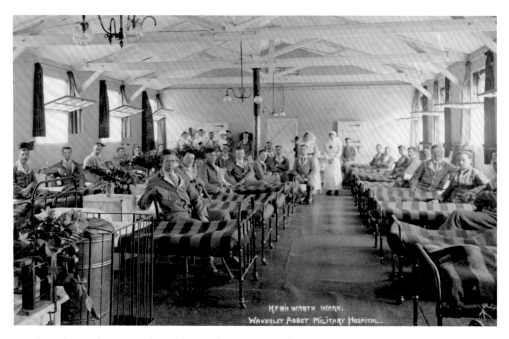

Kenilworth Ward, at Waverley Abbey Military Hospital
Waverley Abbey House in Surrey was the first country house to be converted into a military hospital during the war, and cared for over 5,000 soldiers.

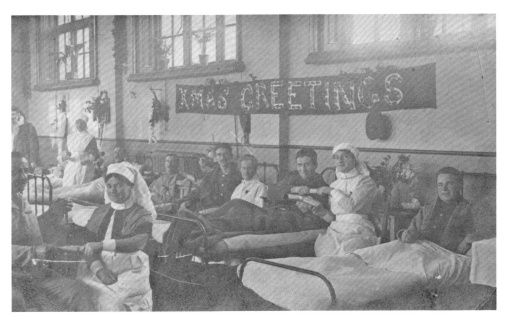

Christmas on a Hospital Ward, 1916
Nurses are pulling crackers with soldiers, and a man is dressed as Father Christmas in the background.

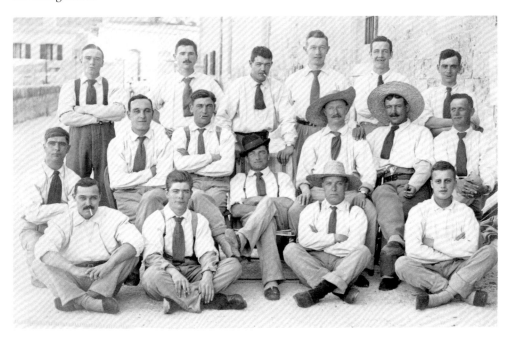

Injured Servicemen at Valletta Hospital in Malta, 1917
Not all injured servicemen could be sent back to Britain, which meant other hospitals had to be utilised. This included the one at Valletta in Malta. This card was sent from there by Harold to Minnie in 1917, which suggests Harold is one of the men pictured. The card has 'on active service' written by hand on the reverse in the top right-hand corner.

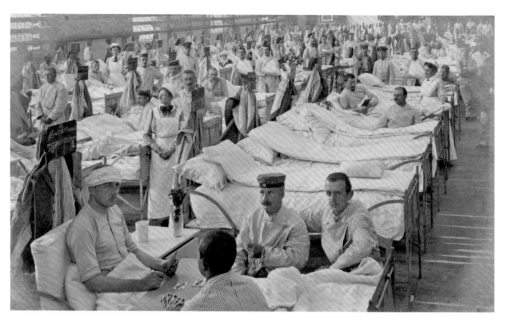

Crowded Hospital, Photograph Taken by Robert Scholz
It wasn't just the British who had many thousands of injured soldiers to look after. The Germans had to cope with their casualties, who were taken back to Germany. This image was probably taken in Gorlitz, the easternmost town in modern Germany. Boredom was a big problem for all injured troops, and ways to pass the time were encouraged, as seen by patients playing cards and reading books.

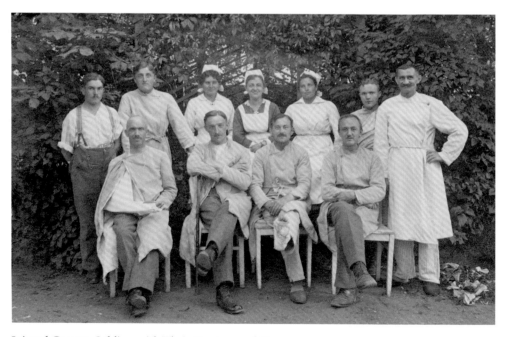

Injured German Soldiers with Their Doctors and Nurses

7

Love Poems, Song–Cards and Propaganda

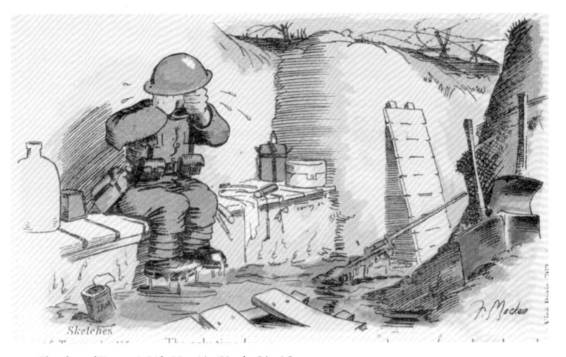

Sketches of Tommy's Life, No. 4 in 'Up the Line' Set
Many postcards promoted messages that encouraged support of the war effort, and often comedy was used to cover up the true horrors being faced. F. Mackain's *Sketches of Tommy's Life* consisted of four sets of postcards: 'In Training', 'At the Base', 'Up the Line' and 'Out on Rest', each containing ten postcards. Little is known about Mackain, but some researchers suggest he was Private Fergus H. E. Mackain, a Canadian, who served with the Royal Fusiliers.

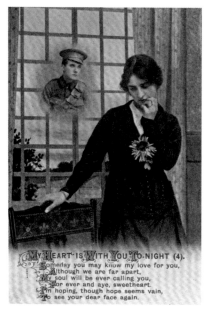
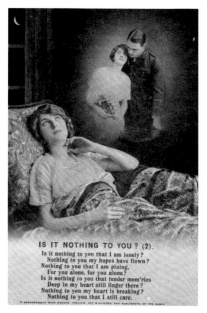

'My Heart is With You Tonight' (*Left*) and 'Is it Nothing to You' (*Right*)
Bamforth was a publishing company that specialised in producing song-cards. The subject matter was generally the same; a young woman with an inset picture of her sweetheart who was away fighting. The production was made simpler in that the people pictured in the cards were employees of Bamforth in their Holmfirth factory. The Vacant Chair is one of the more poignant of the song-cards. Instead of showing the sweetheart it shows their grave, a reality for many women as the war dragged on.

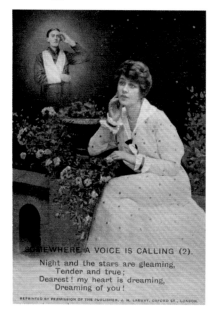
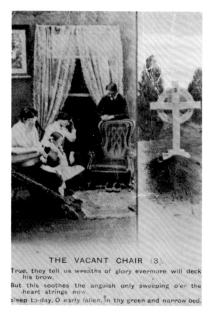

'Somewhere a Voice is Calling' (*Left*) and 'The Vacant Chair' (*Right*)

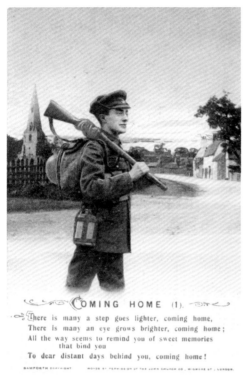

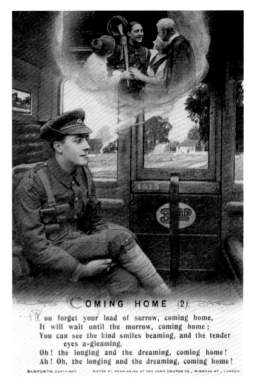

COMING HOME (1).

There is many a step goes lighter, coming home,
There is many an eye grows brighter, coming home;
All the way seems to remind you of sweet memories
that bind you
To dear distant days behind you, coming home!

BAMFORTH COPYRIGHT WORDS BY PERMISSION OF THE JOHN CHURCH CO., WIGMORE ST., LONDON.

COMING HOME (2).

You forget your load of sorrow, coming home,
It will wait until the morrow, coming home;
You can see the kind smiles beaming, and the tender
eyes a-gleaming,
Oh! the longing and the dreaming, coming home!
Ah! Oh, the longing and the dreaming, coming home!

BAMFORTH COPYRIGHT WORDS BY PERMISSION OF THE JOHN CHURCH CO., WIGMORE ST., LONDON.

'Coming Home'

These cards were part of the Bamforth Song Series (series No. 5007/1 and 2). Coming home on leave was a popular sentiment, and featured in many cards.

"I hope to be home
on leave soon."

ADOREMUS IN AETERNUM
ADORE TE DEVOTE

Ecris et dis quand tu reviendras. Write and say you're coming home.

'Write and Say You're Coming Home'

For many soldiers, the hardest thing was being parted from their family. The handwritten message on the back of this card reads, 'My Dear Connie. Are you spending your time like this. I could only get eight cards four for you this week pet & four next. Goodnight little girl. Your Loving Daddy'. It is not clear if this was sent home by a soldier, or just a father away from his daughter.

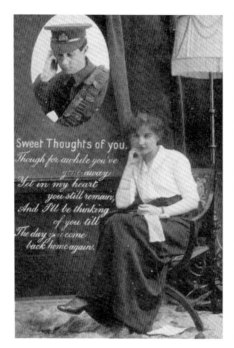
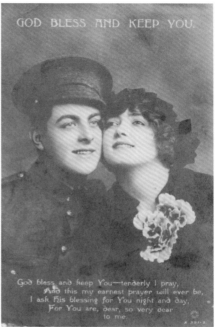

'Sweet Thoughts of You' (*Left*) and 'God Bless and Keep You' (*Right*)
Bamforth was not the only British company producing these types of card. The card on the left is part of the Lovers Series. The card on the right was sent from Harry to Miss G. Rogers, with the card stamped passed by the Censor on February 1918 and addressed to 'Blighty'.

Remembrance Card with a Space on Front for a Name
This card was sent from Pte A. G. Christmas 235152 to his wife in Walton-on-Naze on 10 June 1917. The message is short and sweet, '*From your loving hubby always Alf XXXXXX*'.

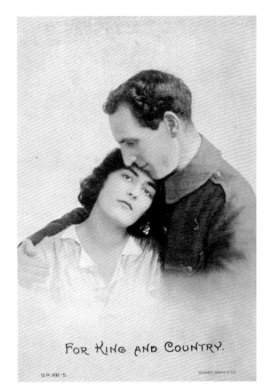

For King and Country.

Propaganda Card Showing the Call of Duty
'For King and Country' was a popular theme to justify the sacrifices being made by young couples who were being separated by the conflict. Life in Britain could be hard for those who were not in the fighting forces, and some women took it upon themselves to hand out white feathers to men still at home as a sign of cowardice.

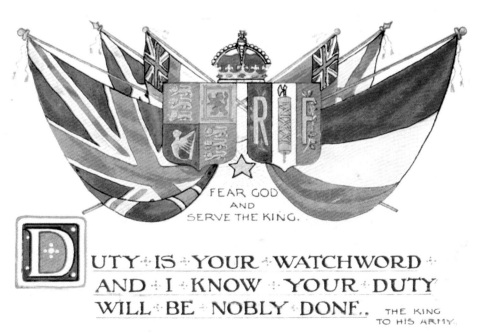

FEAR GOD
AND
SERVE THE KING.

DUTY · IS · YOUR · WATCHWORD ·
AND · I · KNOW · YOUR · DUTY
WILL · BE · NOBLY · DONE. THE KING
TO HIS ARMY

Duty is Your Watchword
This card sent 'from Tom, to Emily', with no other handwritten message, was a typical propaganda card. This card was meant to inspire men to know their duty.

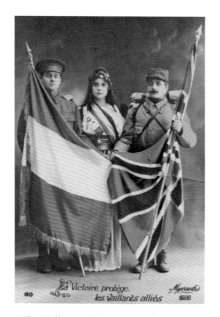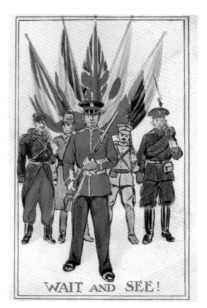

'The Valliant Allies', Posted in 1916 (*Left*) and 'Wait and See!' The Flags of the Allies (*Right*)

Many French propaganda cards involved scenes of soldiers posing and patriotic symbols, showing unity for a common cause. The postcard on the right was part of the Patriotic Series of postcards and was No. 794 in Series II. The crude illustration incorporated the patriotic feeling of the British, and their link to the Allies.

Propaganda Card for the Royal Navy

Following the war, the Merchant Navy gained its own flag – bestowed upon it by King George V following the commercial ships' service during the war – with a union flag in the top left of a red flag, compared to the white ensign flown by the Royal Navy as shown in this card.

HOW I FELT BEFORE THE MEDICAL BOARD.

The Infant--ry!

Comic Postcards
Often the comic postcard tried to capture humour by making the subject a child.

Bamforth's War Cartoon Series No. 5005, Entitled 'Bubbles'
Kaiser 'Bill' became the target for many satirists and appeared on many humorous postcards, as shown here. Bamforth's produced over eighty cards in their anti-Kaiser War Cartoon Series, which either depicted Wilhelm II as himself or as an animal such as a goat, cow, rabbit or dog. This Bamforth card is one of this series, probably drawn by Doug Tempest. The image is loosely based on the 1886 painting by John Everett Millais, and was used in the Pear's soap advertising campaign before the war.

BUBBLES.

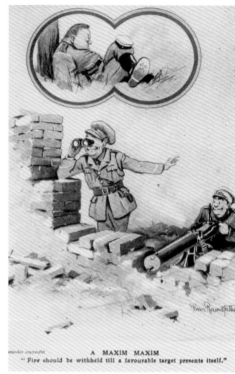

A MAXIM MAXIM

"Fire should be withheld till a favourable target presents itself."

What is this slimy dismal hole
Where oft I'm lurking like a mole
And cursing Germans heart and soul?
 My Dug-Out

Where is it that beneath the floor
The water's rising more and more
And where the roof's a broken door?
 My Dug-Out

Where is it that I try to sleep
Betwixt alarms, when up I leap
And dash through water four feet deep?
 My Dug-Out

Where is it that I'll catch a chill
And lose my only quinine pill
And probably remain until
 I'm dug out?
 My Dug-Out

MY DUG-OUT: A LAY OF THE TRENCHES

Bruce Bairnsfather

Many of the comic cards were from illustrations made by soldiers who had, or were, serving at the front. Captain Bruce Bairnsfather joined the Royal Warwickshire Regiment in 1914, but sustained hearing loss and shellshock at the Second Battle of Ypres. After hospitalisation, he was posted to the 34th Division Headquarters on Salisbury Plain and it was here he developed his cartoon series for the *Bystander*, depicting life in the trenches, which featured Old Bill, a large moustached, balaclava-wearing soldier (depicted as a fancy dress costume in the postcard on page 23).

8

Silk Postcards

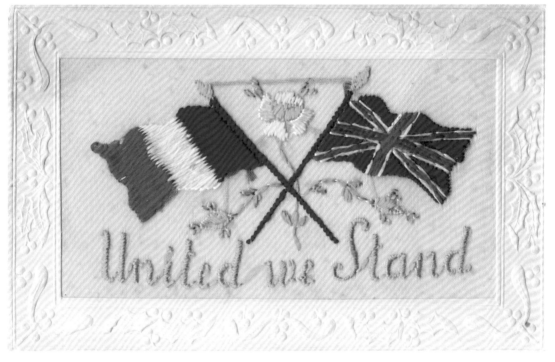

Silk postcards had already come into fashion, but the First World War brought along a new style with a jingoistic tone now filling the text and flags of the Allied nations. Silk postcards became a cottage industry in France, where local women hand stitched the design and then sent them to the factory to be mounted. Soldiers purchased them, even though they were more expensive than a regular card, and often put them into an envelope to protect the delicate design when sending them home.

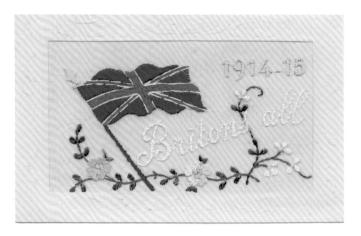

Britons All and Souvenir of Havre, Flags of the Allies
As this card on the right includes the stars and stripes of the USA, it must have been produced in 1917 or 1918.

Happy Birthday
Many cards carried messages of normality. These included Christmas and birthday wishes. The card was sent from a father to his child.

9

The Home Front

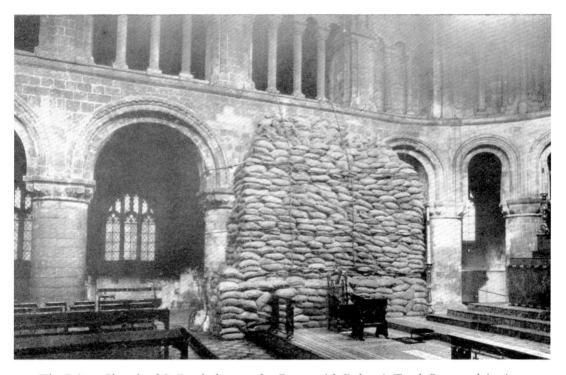

The Priory Church of St Bartholomew the Great, with Rahere's Tomb Protected Against Bombs, 1915
With the risk of air raids growing, monuments in London needed to be protected. The most common protection was the use of sandbags that protected the tomb of Rahere, who is said to have erected the church following his recovery from fever in 1123. Not only did the church survive the First World War raids, it was one of the few churches in London that escaped damage during the Second World War.

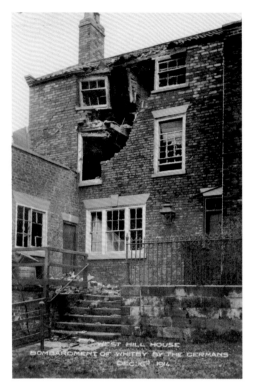

West Hill House, Damaged During a Raid on Whitby, 1914

On 16 December 1914 a German fleet, consisting of the battle cruisers SMS *Seydlitz*, *Von der Tann*, *Moltke* and *Derfflinger*, the cruiser SMS *Blücher*, four light cruisers and eighteen destroyers, launched a raid on Scarborough, Hartlepool and Whitby. The raid killed 137 people and left 592 injured, mostly civilians. Germany hoped to draw out British ships to attack and sink, but bad weather restricted the movement of British vessels. Eventually the two fleets engaged and the Germans, failing to make a decisive blow against the British Fleet, returned south.

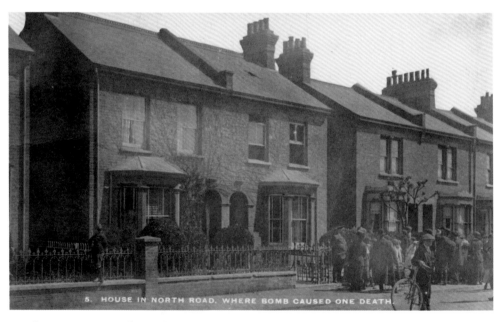

Bomb Damage on North Road, Prittlewell, Southend-on-Sea, 1915

During a Zeppelin raid on 10 May 1915, an incendiary bomb went through the roof (the hole can be seen in the image above) killing Mrs S. Whitwell instantaneously, and Mr Whitwell, suffering from severe injuries, was taken to the Victoria Hospital.

Zeppelin Raids Somewhere in Essex, 24 Sept 1916 (*Right*), at Cuffley on 3 September 1916 and the Raider (*Below*)

During the war, civilian targets gained legitimacy and were attacked from the air by airships and planes. Bombing was not precise and was aimed at demoralising the public. Early on there was no threat to airships, and they could drop bombs with immunity. However, with the development of incendiary bullets, the British were able to take the fight to them. On 3 September 1916, Flt Lt W. L. Robinson shot down a Zeppelin near Cuffley, Hertfordshire. Robinson was awarded the Victoria Cross for his actions, and morale was boosted in Britain. Visitors flocked to the crash site and picked up fragments of the Zeppelin as souvenirs.

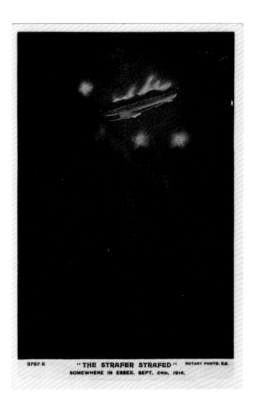

3787 K "THE STRAFER STRAFED" ROTARY PHOTO. E.C.
SOMEWHERE IN ESSEX. SEPT. 24th, 1916.

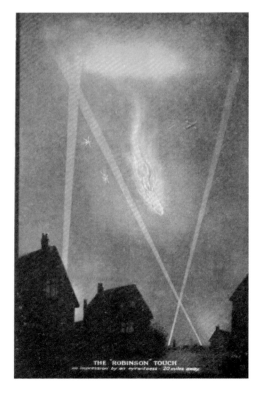

THE "ROBINSON" TOUCH
an impression by an eyewitness - 20 miles away.

THE RAIDER
PUBLICATION SANCTIONED BY OFFICIAL PRESS BUREAU.
PUBLISHING OFFICE:
39, ST. ANDREW'S HILL, E.C. (Copyright)

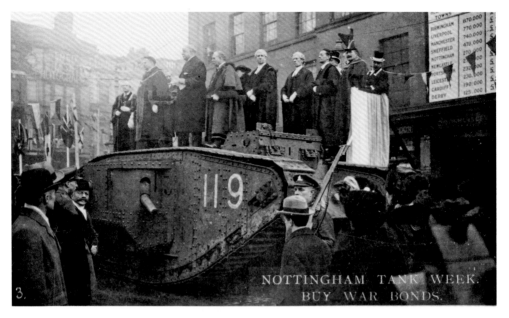

Nottingham Tank Week

Nottingham Tank Week

In 1917, two tanks took part in London's Lord Mayor's Show. The government capitalised on the public's interest by taking six tanks, named *Julian*, *Old Bill*, *Nelson*, *Drake*, *Egbert* and *Iron Ration*, around Britain selling war bonds and war saving certificates from the tank, gaining the name 'tank bank'. Hartlepool raised the most funds and they were given the tank *Egbert* in 1919, in recognition of this achievement, which remained on display until scrapped in 1937.

Collecting for the Flag Day Fund

The Hut Flag Day collected funds for the YMCA Hut Fund, which was aiming to provide shelter to soldiers. On Saturday 5 September 1914, Mrs Morrison (the founder of the First World War Flag Day movement) launched her first collection of the Great War. 3,600 collection tins were issued, and each collector carried a tray laden with flags. The sellers captured public sympathies and flag days continued throughout the war to raise funds.

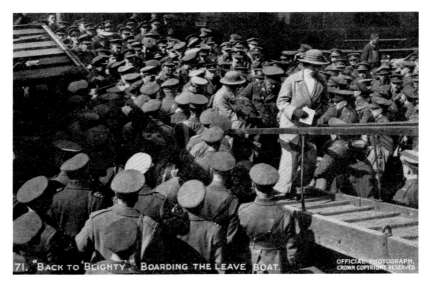

'Back to Blighty', Boarding the Leave Boat
With the fighting so close to Britain, and modern transport links, troops were given leave back in the UK to meet up with family. Many men found it difficult to go from the stresses of trench warfare to quiet family life, and found they couldn't talk about their experiences in fear of upsetting loved ones.

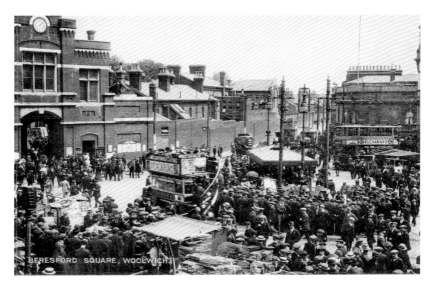

Workers Leaving the Woolwich Arsenal, Beresford Square, Woolwich London, 1914
At its peak during the First World War, the Woolwich Arsenal employed 80,000 people. Expansion of production in 1915 saw the building of 1,300 new homes at the Well Hall Estate at Eltham to help accommodate the workforce. As well as its military production, the Royal Arsenal also manufactured the memorial plaques given to the next of kin of service personnel killed on active service between 1914 and 18. This picture dates from the war, as the newsstand reports, 'Churchill's Five Ways To Win the War'.

"Doing her Bit"

THE LADY "BOBBY"

The Rise of the Female 'Bobby'
Vacancies in the workforce were a direct result of the large number of men in active service. Prior to the war, suffragettes were gaining support in Britain, but on declaration of war their leader, Emmeline Pankhurst, called a halt to militant suffrage activism and encouraged women to support the fighting men by filling work places left vacant by men going to war. This is shown in this 1917 postcard of a female police officer. This action was responsible for women over thirty being given the vote in 1918.

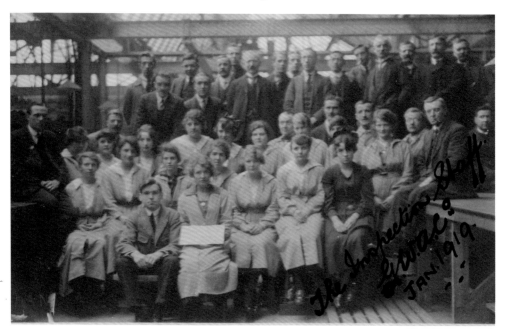

Inspection Staff at GWAC, January 1919
Even though this was taken after Armistice, the postcard shows a workforce dominated by women and older men, and probably commemorates the staff's war work.

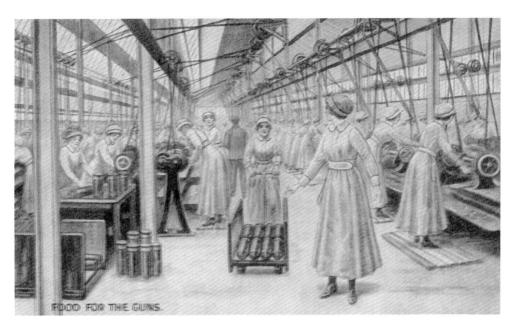

Food for the Guns

This postcard was produced as a 'War Bond Campaign Post Card' issued in connection with the National War Savings Committee's Campaigns. The image, design No. 8, was supplied by the Ministry of Information and was produced by A. M. Davis & Co. Quality Cards, London. Even though they were crudely illustrated and gave a sanitised view of factory life, they were popular.

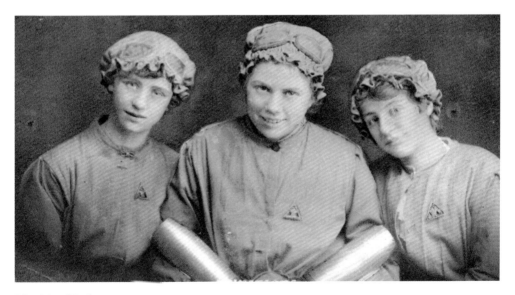

Munition Workers

This propaganda card illustrates the female war worker in a munitions factory. It was arguably the most important job on the home front, considering how much ammunition was being used by the Army and Navy. Munition workers were not only exposed to death from accidental explosions, but also regular inhalation and touching the chemicals left many with serious health problems.

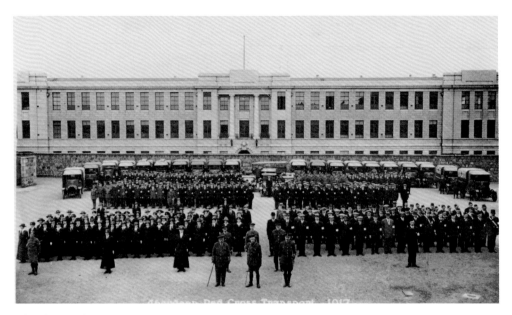

Aberdeen Red Cross Transport, 1917

During the war, the British Red Cross provided 90,000 volunteers to help wounded and sick soldiers in the UK and abroad. They established 1,786 auxiliary hospitals and staffed ambulances, hospital trains and motor launches used to evacuate wounded soldiers back to Britain. They also dispatched over 47,000 food parcels a month to prisoners of war and wounded soldiers. Wealthy families supported the Red Cross through donating money, and sometimes by opening their homes as temporary hospitals.

First Aiders in Exeter, pictured in 1919

It is likely that this group shot was taken to commemorate the war work of some Exeter first-aiders at the end of the war. The first aiders were there to support wounded soldiers and people in the town in the event of an enemy air raid.

10

Commemorating Peace

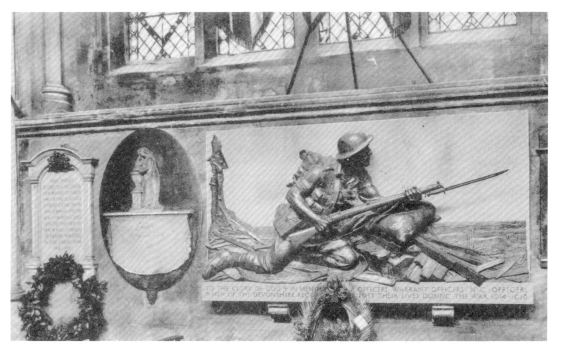

Devonshire Regiment Memorial in Exeter Cathedral, to the Officers and Men Who Served During 1914–18

Throughout Britain, cathedrals started to commemorate their local regiment's involvement in the war. The Devonshire Regiment fought on the Western Front and in Mesopotamia, seeing action in the Battles at the Aisne (1914), Loos (1915) and the Somme (1916). The regiment's losses on the first day of the Battle of the Somme at Mametz were marked by the establishment of the Devonshire Cemetery, where the dead were buried in the remains of their frontline trench. A memorial at the cemetery's entrance bears the words, 'The Devonshires held this trench. The Devonshires hold it still'. On the 28 May 1918, the 2nd Battalion made a last stand at Bois de Butte, on the Aisne, to buy time for the British front line to be stabilised after heavy German attacks.

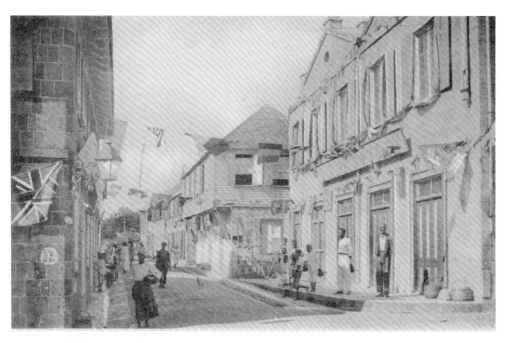

Armistice Celebration in Plymouth, Montserrat

With the Armistice in November 1918, communities could celebrate the end of the fighting. However, for many it wasn't a time to celebrate. Nearly every family in Britain had lost a member or seen their loved ones horrifically injured. A whole generation of young men had been decimated. Communities throughout Britain and the Empire raised banners, bunting, flags and peace signs (as seen above, in Montserrat) and there were church services and community gatherings.

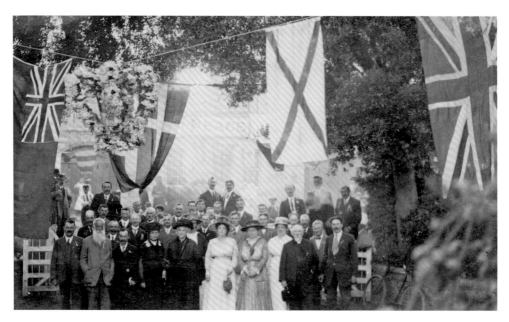

Unidentified Peace Party in Britain

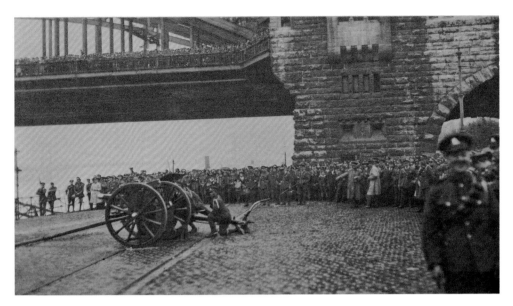

The First Gun to Fire Across the Rhine, 28 June 1919

The Treaty of Versailles was signed on 28 June 1919, which formally ended the First World War. At 6 p. m. on that day, a 101 gun salute was fired across the Rhine at the Hohenzollern Bridge, Cologne. The salute was fired by the London Division Artillery of the 190th Brigade RFA. A set of six postcards were produced by Hunters of Buxton, Derbyshire to commemorate the moment. All of the soldiers involved with firing the guns were given a scroll to mark the event, with their name handwritten and signed by Brigadier General Oldfield, commander of the London Divisional Artillery.

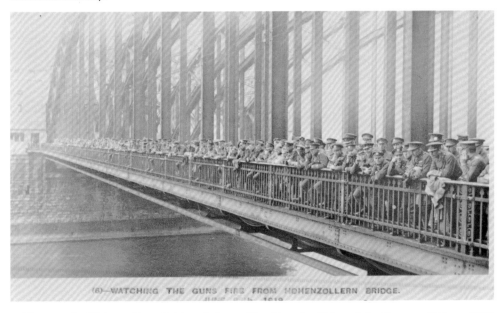

Soldiers on the Hohenzollern Bridge, Cologne Watching the Firing of the Guns on 28 June 1919

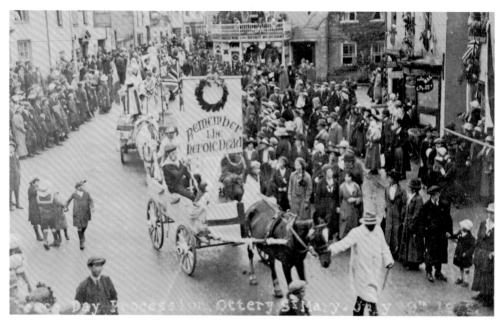

Peace Day Procession, Ottery St Mary, Devon, 19 July 1919

Communities waited until after the formal peace agreement was signed in June 1919 before they celebrated. July 19 was the official national day of celebration. Many towns held commemorations to honour the local men who had served, especially those who had been killed or injured, as shown by the banner in the postcard that asked those present to 'Remember the Heroic Dead', listed below on the memorial in the local church.

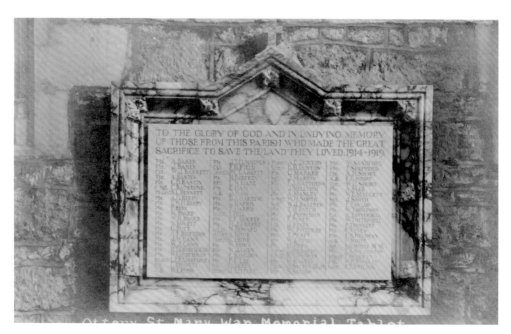

First World War Memorial in Ottery St Mary Church, Devon

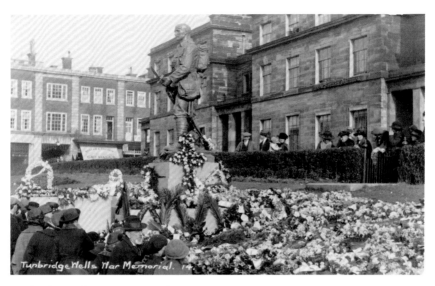

Tunbridge Wells War Memorial

First World War losses were unimaginable. In total, over 10 million military personnel were killed in the conflict, of which 886,000 were from the British armed forces. To honour their memory, communities throughout Britain erected war memorials, often listing the names of the local men who fell in battle. From 1920, many postcards of general town and village scenes started to show these memorials. This postcard probably shows the first service to be held at the Tunbridge Wells memorial.

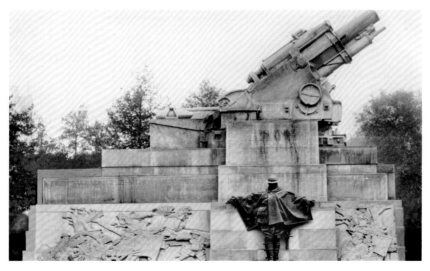

The Royal Artillery Memorial at Hyde Park Corner, London

This memorial, designed by Charles Jagger and Lionel Pearson, was unveiled in 1925 to remember the 49,076 members of the Royal Regiment of Artillery who died. The sculpture is of a howitzer, with a bronze statue of a soldier on each side, depicting a driver, an artillery captain, a shell carrier and a dead soldier. When unveiled, the dead soldier drew major criticism, often compared unfavourably to the refined Cenotaph.

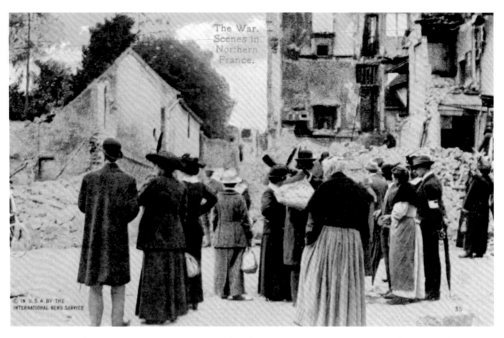

Scenes in Northern France, Post-1918, Maybe Showing Tourists Visiting Battle Grounds
The card reads, 'Before Rheims, Senlis was razed to the ground by the German army. It was a Beautiful Old-World town.' Surprisingly, after the war ended, battlefields immediately became tourist attractions. Some trenches were preserved as attractions, while old tourist sites demolished in the war became beacons for this new industry. Visitors ranged from those wanting to see where loved ones fought and died, to those with a macabre fascination. By the 1920s, postcard sets were being produced of the sanitised, preserved trenches.

Acknowledgement

The author would like to dedicate this book to all the people who fought during the First World War and worked on the Home Front in support of the fighting men and women, as well as the civilian population.

I would like to thank my wife, Vicky, and son, Frederick, for their support during the production of this book. I would also like to thank Peter Harris for the use of his image of Ottery St Mary volunteers, page 19. The rest of the images come from the Sands of Time Consultancy archive, owned by the author.